WORKING HANDS

NUMBER EIGHT CLAYTON WHEAT WILLIAMS TEXAS LIFE SERIES

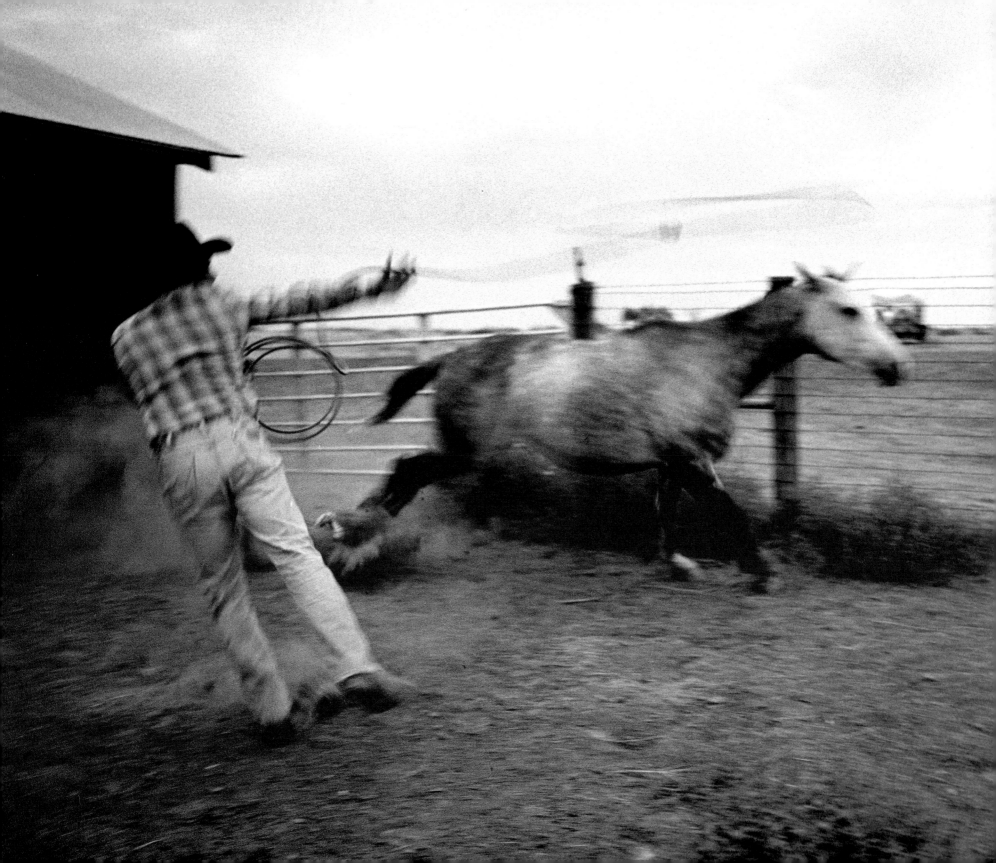

3

EARLY MORNING ROPING 1981

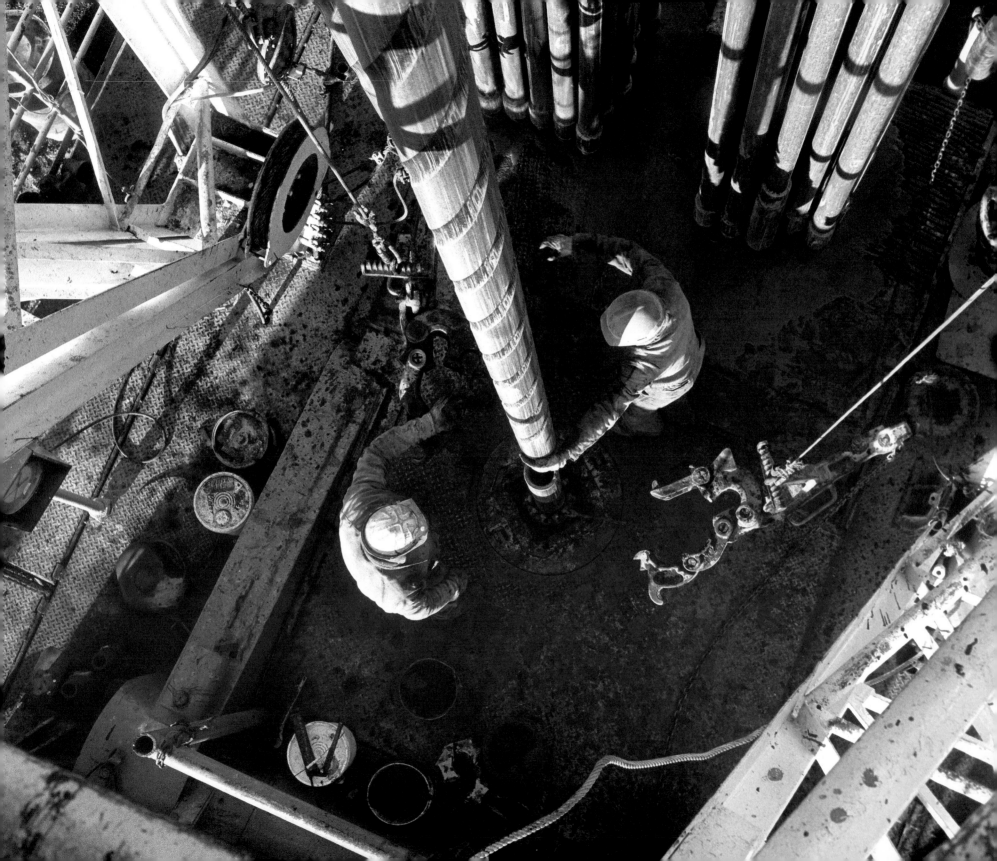

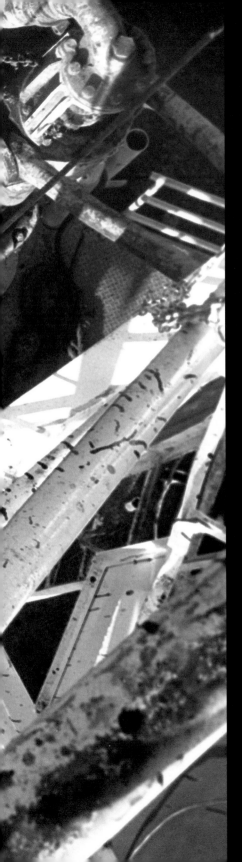

5

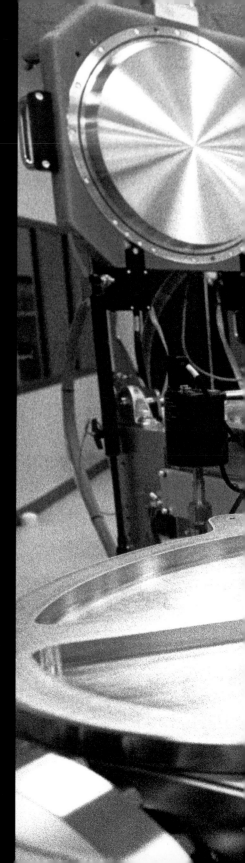

MICROCHIP MANUFACTURING TOOL 1994

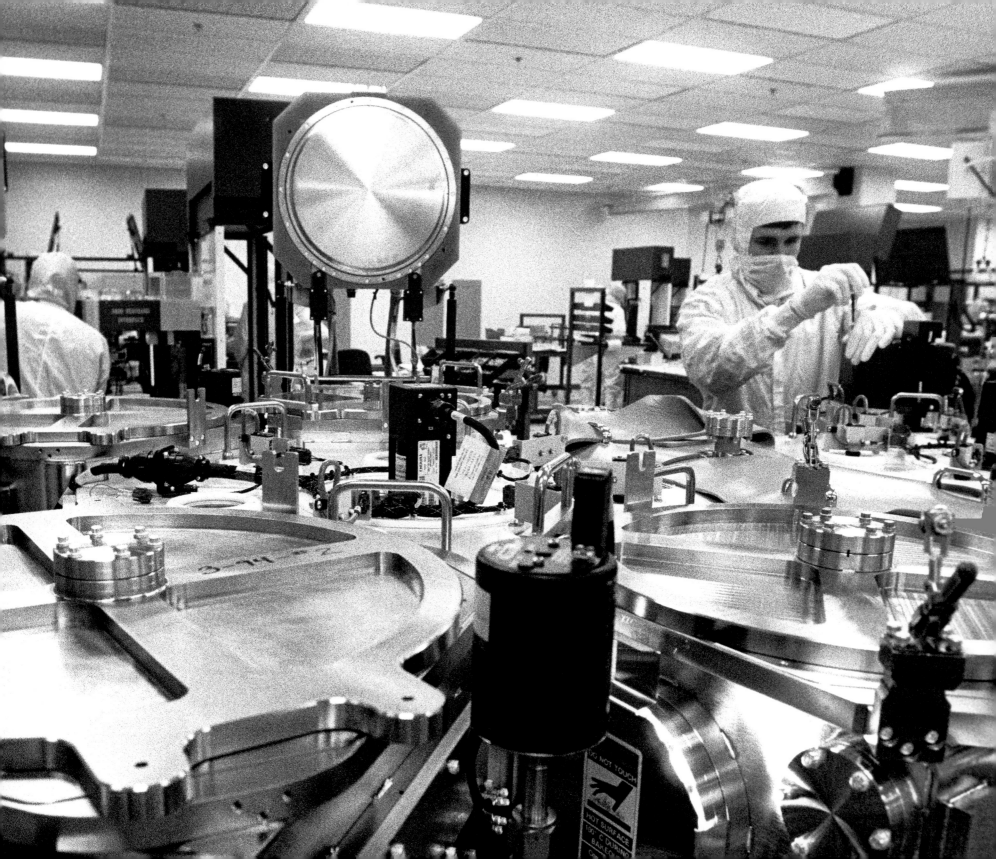

WORKING HANDS

Photographs and text by

RICK WILLIAMS

TEXAS A&M UNIVERSITY PRESS COLLEGE STATION

A generous grant from Applied Materials, Inc.,

has helped to underwrite the publication costs of this volume.

The paper used in this book meets the minimum requirements

of the American National Standard for Permanence

of Paper for Printed Library Materials, Z39.48-1984.

Binding materials have been chosen for durability.

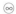

Library of Congress Cataloging-in-Publication Data

Williams, Rick, 1946–

 Working hands / text and photographs by Rick Williams—1st ed.

 p. cm.—(Clayton Wheat Williams Texas life series no. 8)

 ISBN 0-89096-955-8 (cloth)

 1. Labor—Texas—Pictorial works. 2. Working class—Texas—Pictorial works.

 3. Cowboys—Texas—Pictorial works. 4. Petroleum workers—Texas—

 Pictorial works. 5. Microelectronics industry—Texas—Employees—Pictorial works.

 6. Working class—Texas—Interviews. 7. Photography of hands. I. Title. II. Series.

HD8083.T4 W55 2000

305.5'62'09764—dc21

 00-037802

Working Hands was composed into type in QuarkXpress, in 10 point ITC Officina Serif, with 14.7 points of spacing between the lines. ITC Officina Serif was selected for display. The book was designed by D. J. Stout, with design assistance from Lori Braun. The book was printed offset by The Stinehour Press, in Lunenburg, Vermont, and bound by Acme Bookbinding, in Charlestown, Massachusetts.

This book is dedicated to those who gave the most.

My wife, **Julianne Newton,** who has been so constant in her love and support and who has edited the text and images in this book so many times that it is as much hers as mine.

My children, **Josh Williams, Kate Williams, and Matt Newton,** who have been and who continue to be sources of inspiration and strength.

The **cowboys, roughnecks, and high-tech workers** who gave so generously of their lives and whose images and wisdom fill these pages.

Contents

PREFACE

During the twenty-year course of this work, my life and my photography have evolved, or perhaps integrated, to focus on the dynamic balance between grace and power. For me personally, grace represents the strength and choice to listen to the unspoken, the inner guide within us all. Power is the strength and choice to live in accordance with that guidance. Balance is the integration of grace and power as one.

My photography and the related interactions with the people and things I photograph have been an integral part of the process of learning to live close to this dynamic balance between grace and power. From the beginning, long before I was consciously aware of this concept of balance, my images symbolically portrayed this integrative unity. It has taken me two decades to begin to understand rationally what I have known intuitively all along.

Hand on the Saddle, an early image which appears on the cover of this book, exemplifies this process. The image was made in 1981, during the first year of this project, as Gary Hebel mounted his horse. It happened in an instant. There is one frame. I knew it when I saw it. My subconscious could frame it as an image, though I could not articulate it with words.

When we look at Hand on the Saddle from a symbolic perspective, we already know that the cowboy icon represents a rugged integrity that suggests the heroic. The dark hat, tilted down, represents looking inward, or the inner self. The clinched fists represent external determination or power, and the horse represents movement or change. The symbolic interplay of the heroic with the inner self and external determination sets up a dynamic tension on an intuitive level corresponding to the tension of the visual elements in the image. Grace and power are one.

Twenty years later I am acutely aware that this same philosophy underlies virtually every image I take, though most often I do not think about putting it there. My conscious awareness has slowly evolved to understand that the balance of grace and power underlies this work and guides my life, my art, and my academic research and teaching.

To me, this suggests that, beyond its literal and representational meanings, personal imagery not only reflects the present inner state of the artist but also points toward the continued awareness and development of the intuitive self.

On the surface, my original motivation for what has become this book was a commercial photography assignment mixed with the excitement of chasing romantic cowboy ideals and of developing a better understanding of my roots as a sixth-generation Texan. Yet, on that first morning on the Green Ranch, when I stood alone in the pre-dawn light looking over thousands of acres I had never seen before, I sensed a transcendent wisdom that guided my early artistic visions. Over time my method shifted into a more conscious, ethnographic and sociological approach that included research, though I was always

aware of the influence of an inner, driving force that I could not yet put into words. During the first years of the project, I worked primarily with cowboys and roughnecks and pursued the work as an academic study to produce a Master's thesis—"Commonground: Cowboys and Roughnecks." I recorded many hours of ethnographic interviews and used a values sampler to determine the stated values of nearly every cowboy and roughneck in the area.

When my data indicated no significant differences between the stated value systems of cowboys and roughnecks, I hypothesized that, in this community, the urbanization I was looking for might have already taken place. This led me to the unwanted conclusion that a broader and deeper ethnographic study, using interviews to correlate intergenerational values with behavior, was needed to understand the rural-to-urban dynamics. Fortunately, that inner, driving force moved into the foreground, and I realized I had lost most of my excitement and passion for the project. Somewhere in my academic effort to quantify the qualitative and to explain in words the inexpressible, I had lost my way.

During this time, my infatuation with cowboy life and rural community had diminished. While I knew it was important to avoid romanticizing rural community or rural values, I also believed important clues to our heritage as a nation and a people were hidden in the values of rural community life. I believed that the face and the soul of our rural heritage were rapidly giving way to technology and to a more urban lifestyle with values that were quite different in pace and character than those embraced by rural communities. It seemed to me that, beyond the romantic, some of those rural values and traditions must be worth recording and preserving in order to pass them on to our children as enrichments and foundations for their lives.

For me, the search for the answer to the question of what values of rural community are worth passing on did not lie exclusively in systematic research but in the integration of that academic pursuit with the more intuitive and intimate sharing and recording of daily life and work as artistic experience and expression.

This realization kindled a sense of renewed passion and discovery, so that, several years into the project, I returned to a more artistic method that integrated my original intuitive approach to image making within a consciously directed ethnographic format. I followed my intuition as I participated in and recorded the work and lifestyles of people of diverse, yet closely related cultures. On one level I know that much of what I am seeking is already within me: that many of the discoveries I make in the sharing of my life and the creation of art with these people and with you are self-discoveries and self-revelations. Yet focusing on the lives of others in the images suggests that I am not simply expressing my own ideas. The images of real people at work are both interpersonally representative and intrapersonally symbolic, simultaneously graceful and powerful.

For me, part of the value of this work is that it reveals more of the great mystery, suggesting that the evolution and revelation of the self is, in many ways, integrally dependent upon an intimate interdependence with and understanding of other people and other things. In this transcendent sharing, life becomes art and art reveals the omnipresence of the interplay and balance of grace and power within the self and between the self and the community.

I have realized for many years that I often do not know, at the time of the making, why I take a particular image in a certain way at a given instant. It is not that I do not consider what I am doing and why, but rather that I know there is always more than my conscious awareness and decisions driving the image making.

Most images are made in a split second. Each image that you see existed in real time for less than a second. Most

often I simply turned, saw, knew, reflexively framed, focused, set exposure, and pushed the shutter—all in an instant. For each picture there is only one frame where all of the dynamics come together at the same moment—as Cartier-Bresson called it, the decisive moment. Yet, the story the images tell about the dynamic balance of grace and power transcends time and underlies all of my work in the same way that it guides my life.

As I look at some of the earliest images, and all that follow, I see nonconscious guideposts, symbolically pointing the direction to the assimilation and balance of archetypal principles. At the same time I am seeing and photographing expressions of that balance in the work lives of people in diverse, seemingly antithetical industries and cultures.

So, my conscious thinking about the images I was producing and their representation of the integration of diverse Texas cultures closely paralleled the more intuitive, nonconscious process of creating a personal, symbolic metaphor—a sort of psychological self-portrait. Though I was not aware of this connection for many years, I am certain now that the nonconscious motivations more often served as a guide for my image making than did my conscious thoughts.

Acknowledgments

When a project spans twenty years there are hundreds of people and organizations that contribute to its successes. I am grateful to all of them. I particularly want to remember:

The people of Albany, Texas, and Applied Materials, Inc., who gave me such generous and intimate access to their lives—especially Bob and Nancy Green, Bill and Elizabeth Green, Billy and Liz Green, A. V. and Pat Jones, Watt Matthews, Reilly Nail, Betsy and Don Koch, Bennie Peacock, Gary Hebel, Melvin Gayle, Steve Taylor, Sam Bryant, and Jim Morgan.

Those friends and colleagues who have so often been there when needed—especially my parents, Fred and Iris Williams, who are always there with encouragement and support; Dave Hamrick, without whom this book would still be in my file cabinet; Tim McClure and Steve Gurasich, who sent me to West Texas the first time; Nancy Springer Baldwin, who was there to help start and sustain the early work; Roy Flukinger, who often put me in the right place at the right time; the staff of Texas A&M University Press, who helped bring all of the disjointed parts together; and D. J. Stout, whose superb design talents made it all work.

Many other friends who so often advised and reminded me of the value of this work when I needed it most. They include Ave Bonar, Steve Clark, Mike Murphy, Mary Lee Edwards, Sharon Stewart, J. B. Colson, Jim Tankard, Gerry King, Ingrid Schmidt, Anne Tucker, Tom Southall, Fred Baldwin, Wendy Watriss, David Wharton, Laura Lein, Mary Margaret Farabee, Bill Wright, Bob O'Connor, and Graciela Kartofel.

The following organizations, which graciously provided support to further this long-term project: Applied Materials, Inc., Advanced Micro Devices, The Old Jail Museum, The Austin Arts Commission, The Texas Photographic Society, The Houston Center for Photography, The Texas Historical Foundation, Texas Monthly Press, The Texas Committee for the Humanities, The Humanities Resource Center, The National Endowment for the Humanities, The Meadows Foundation, The Brown Foundation, Houston Fotofest, The Museum of Fine Arts-Houston, The Harry Ransom Humanities Research Center at the University of Texas at Austin, The Amon Carter Museum of Western Art, Universidad Nacional Autonomo de Mexico, The Instituto Cultural Mexicano, and The Instituto Culturo Peruano.

WITH THEIR OWN HANDS

Texans at Work

Most Texans spend more time working than anything else. Work does not just support the lifestyles they choose to lead; in many ways it helps define both the structure and the meaning of daily life.

In Texas, a succession of industries—cattle, oil, and now high-tech—have formed the backbone of the economy and thus have helped shape the daily lives of men and women and the communities in which they live. Indeed, others have traditionally assumed all Texans were either cowboys or oil-rich. If they have not associated the emerging computer industry with Texas daily life, it may be because of the recent and rapid pace at which this industry has transformed the Texas economy and thus the lives of Texans.

In a mere twenty years, the high-tech industry has outpaced ranching and oil, both in terms of the number of workers employed and as a socioeconomic force. The pace and influence of the transition continues to increase from areas like Austin and Houston into the state and beyond. Though there has been a succession from an agrarian to a mechanical to a technological environment, these three primary industries have supplemented rather than supplanted each other. They now represent a kind of three-legged stool on which Texas sits and on which Texans work.

As I have photographed and interviewed people at work in Texas since 1980, I have participated in this amazing transition on all three fronts. Slowly, it has become clear that these three seemingly antithetical industries share much in common. I have spent most of my time with those people who make up the basic workforce of these economic powers—the cowboys, the roughnecks, and the micro-industry technicians. In the pictures that follow, I try to portray the continuities and commonalities, as well as the differences, that characterize the work and work life of those who spend their days in the saddle, on the oil rigs, and in high-tech clean rooms. In their work, I have found grace and power, motion and stillness, tradition and change as these Texans help shape, with their own hands, the communities and traditions they will pass on to their children.

A Wondrous Hostility The ranching, oil, and high-tech industries of Texas connect on a primal level, a level as primal as the historic lands of the Texas Great Plains. But the land supports more than just a physical connection. The way the different workers relate to and use the land reveals the nature and characteristics of the slow, but steady transformation from a rural to a more urban socio-economic structure in Texas: from an agrarian culture (circa 1840) to a mechanical/industrial culture (circa 1920) to an electronic/technological culture (circa 1980).

These workers—beginning with the cowboys and followed by the roughnecks and high-tech workers—have driven and shaped the Texas socioeconomic landscape (the socialscape, as I have called it) and the Texas mystique over the last one hundred

Hand on the Saddle

Chill morning air, just behind the false dawn, suspends lingering scents of wildness. Subtle sounds of animal flight from intrusive human presence mingle with wafted scents of leather, horsehide, and dung. You and the mare, in the passion of blood-red rising, the cinch snugged tight, soft reins over white-knuckled fist, watch the light-cracked dawn climb. She scuffs the skittish dirt. Dust rises among hoofs and spurs. Hot breath singes cold air in snorts, hers and yours, as, in a single sweeping moment's movement, you stretch for the saddle. She crouches and skitters from you, your foot climbing invisible steps, stretching for the loose stirrup swinging. Her belly tensing, she shifts into you. You catch the stirrup sure, leaning into her power, and just in that instant, before she darts forward, before your hind, tip-toed foot fully leaves the ground to mount her, you and she are held in time suspended. Here, neither you nor she is sure or unsure of intent or outcome; a moment, this, where grace and power hang in the balance. Either you balk together and try again, or together you rise into the air, embracing the unity that carries you, horse and rider, into the presence of all who have ridden this land together before you and all who follow.

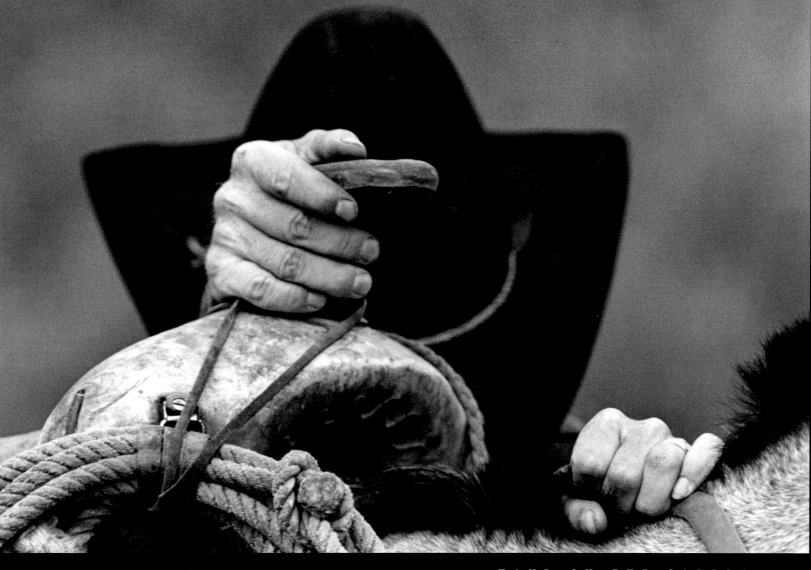

and fifty years. Today their stories converge. The integration and organization of smaller cultures around the corporate banners of a global society shift both the location and the ethos of our sense of community from the rural landscape to the high-tech clean rooms and the boardrooms on the Texas plains.

A broad knowledge of the significant characteristics of these diverse and powerful industries—both their similarities and their dissimilarities—enhances a critical understanding of the economic and cultural effects of this transition and the subsequent transformations of values and traditions of Texas and of Texans. I emphasize a broad knowledge because the type of visual understanding this book offers is not the typical format used to assess economic and cultural transitions. Yet the view is valid in that the images themselves, and their juxtaposition in the book, allow us to see characteristics of and relationships among these groups that we could see in no other way. They thus add a unique new knowledge and new meaning to our overall understanding of the transformation of the Texas economy and culture.

Most of my early thinking in this project examined the integration of rural and urban cultures and how that integration affected the traditional values and lives of rural people. Since 70 percent of the U.S. population lived in rural settings at the beginning of the twentieth century, most of us have strong roots in rural values and traditions. Today, about 70 percent of the U.S. population is urban. Because of our history, this rapid, ongoing change of our socialscape and the subsequent transformation of our agrarian value system and traditions should be of interest to us. Our values and traditions shape our lives and relationships by reminding us who we are and how we think and act and why. In a rapidly changing culture influenced more and more by corporate values and dominated by media-generated imagery, our history and the beliefs and customs that help define our identity are easily lost. And with the loss of our historical identity as individuals and as a people, the primal balance between grace and power rapidly disintegrates. In this rapid and unchecked transformation process, I fear that the wonder of living may be lost to a hostile environment that is committed to competition and quantity, rather than to community and quality of life. I am not suggesting that the rural is utopian, or that the corporate is sinister, or even that change itself is the substance of the problem. I am suggesting that the increasingly rapid pace of change marginalizes our need to reflect and to consider the direction and effect of change on ourselves and our community. Therefore, when this unprecedented pace is applied to unchecked development toward a multinational, corporate culture, the distribution of wealth becomes more unequal and the foundation of power narrows, and in this process the opportunity is lost for a symbiotic balance that includes grace as power's complement. The ideal of balance between quantity and quality is one of the primary cultural values from our rural ancestors that may be worth passing on to posterity. I believe it is worth reflection.

Common Ground The ancient plains and grasslands that we now call Texas provide, perhaps, the most basic connection among these diverse groups. From times prehistoric—from the emergence of the native ancients into the tribes of Choctaw, Cherokee, Arapaho, Apache, Ojibwa, Kiowa, Comanche, Navajo, and many others—the reverence for mother earth and the dependence on the earth for sustenance and strength permeated the soul of this land. In essence and spirit, beyond history and culture, these early peoples established a tradition of balance and unity with the land that transcends culture and time in both its metaphorical and its literal significance to community life.

Thus the land and the influence of the peoples who came before the Spanish, the French, and other immigrants who

later overran the Great Plains helped shape the lifestyles and values of early European settlers on the plains. In turn, these settlers farmed, fenced, and raised cattle on the plains and passed on some of the aboriginal, land-based values and traditions to contemporary ranching cultures.

Though these early settlers worked the land with strength and perseverance, for all their efforts, they were ultimately dependent on the land and on rain and sun and health. They faced the problems of drought and cold, often in the relative isolation of rural ranch communities. They were aware of the environment and the need to take care of the land, as well as to take from it. They learned to live with and adjust to a life dependent upon forces outside of their own control. This dependence on the uncontrollable forces of nature, in relative isolation, produced a rural lifestyle characterized by interdependence, individual and community efforts toward the common good, communal sharing of prosperity and grief, a rigid social and class structure, and resistance to rapid, uncontrolled change.

Even today, ranchers and cowboys use and care for the land from an agricultural understanding that they are also dependent upon the land and upon weather, water, and soil for the welfare of their crops, animals, and families. One example of this awareness is found in the notebooks maintained by Watt Matthews, the late patron of Lambshead Ranch. For many years, the first thing Watt did in the early morning was call the other ranchers in the area and record the rainfall on their ranches. His notebooks, published as *Lambshead Legacy* (Texas A&M University Press, 1997), provide records of these significant agricultural trends over many decades and illustrate both a dependence on and a concern for the land and weather.

In the early part of the twentieth century, wildcatters and roughnecks began to work the same land as the cowboys. Work in the oilfields was more mechanical than ranching, however; machines and technical acumen helped workers overcome and defy the effects of nature and to drill and pump petroleum from the earth's inner depths. Although some oil workers had been ranchers and cowboys, many of these pioneers of modernism were formally educated in technical fields, had no direct roots in the early rural traditions of the area, and were interested in the land primarily for its subsurface riches.

Their work and the tools of their trade continue to require technical skills that depend primarily upon science, machinery, and strong backs, rather than natural forces over which they have little or no control. Their lifestyle, following the development of fields, reflects such distinct characteristics as independence and mobility, a strong sense of competition, new ideas connected with the desire and ability to change things which do not work for them, and a flexible social structure based on upward social and economic mobility.

Derricks and pumps did not represent the final transformation to the landscape, however. Where cows once ranged, large, modern plants with carefully groomed grounds now stand. Over the last two decades, from the silicon valleys of California to the plains and hills of Texas, high-tech companies have transformed the farming and ranching prairies into smoothly mown lawns supporting sleekly designed architecture. Many of the new structures house clean rooms designed to shut out any trace of nature's interference in the production of computer chips on postmodern assembly lines that employ engineers and highly trained technical workers. The urban values reflected in these high-tech cultures are highly competitive and predominately corporate, requiring teams to work against the clock and each other for the good of the company and its shareholders. While salaries and benefits provide well for the basic necessities, life centers around and depends upon the welfare of the company. In many ways the company itself has replaced the small community, providing work, social interaction, and opportunities for public service.

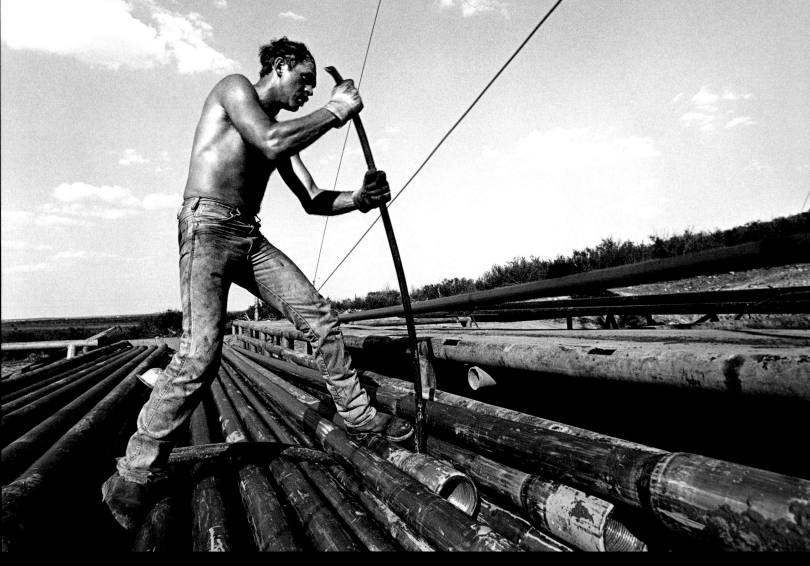

STACKING PIPE 1984

Standing Sweat Soaked Still

Standing still in tensed motion. Muscle bends steel to the task. Sweat-soaked dripping skin splatters droplets wanting to run on steel pipes and white-paint-chipped deck scuffed down to the smooth, boot-polished metal—hot, so hot sweat sizzles and vaporizes before pools can gather.

On the deck, raised ten, maybe twelve, feet off the prairie ground, ground bladed clean to dirt, dry all around, save the mud pit, steel on steel turns three thousand feet of six-inch pipe. Bit-tipped drilling pipe cuts, grinding down, deeper, inch by foot through the dirt and the shale, closer and closer to the alleged ancient ruins of organic decay for which we labor. Day after day, night and day alike run into sameness at time-and-a-half-plus-ten-cents in the crow's nest.

Deafening drone of mud-caked motors unmuffled roar on against the prairie's quiet indifference to mechanical presence. Living creatures are driven afar by the drone and clang of steel on steel, sledge to spike, chain to pipe, cable to lever. All are subdued by the practiced flick of skin and bone joints of muscled men, hard-hatted beneath the relentless sun of the clear western sky, where cowboys still ride and cattle bellow against the iron.

This transition, from an agrarian to a technologically based culture, embodies a clear, linear, historical movement from working on the land, to working on steel platforms above the land, to working in buildings that are on the land but completely separated from it. These newer, high-tech structures are designed to maintain controlled-environment clean rooms that eliminate all organic, land-based materials, including dust or particles from the human body. Along with this movement away from direct contact with the land and the body there is an associated characteristic of the workers' becoming more transient. As they become more involved in the competitive aspects of technology, they follow the work and the pay from company to company, nation to nation. Consequently they often are less connected by daily, long-term working relationships and more isolated and anonymous in both their professional relationships and their professional appearance in clean-room bunny-suits.

As representatives of the three primary economic forces that have shaped the landscape and work life of Texas for the last one hundred and fifty years, cowboys, roughnecks, and high-tech workers are connected not only by the land they occupy but today by the economic interplay of one industry with the other. Ranches near Albany, such as Lambshead, the Nail, and the Green, have been owned by the same families since the mid- to late-nineteenth century. While the stewardship of farms and ranches in the United States has seen a severe decline and shift from traditional family to trust or corporate control in recent decades, some of the larger ranches in this area exceed fifty thousand acres of oil-rich land that is still owned by traditional ranch families. Much of the oil needed to produce gasoline and petroleum products and parts for computer components that run our cars, our businesses, and our communications industries lies below the surface of traditionally owned ranch lands. In many instances the production of oil has sustained ranches in lean agricultural years and helped keep the land in traditional use and ownership. Likewise, the need for petroleum products in the burgeoning high-tech industries has helped rebuild the failing oil companies of the late 1980s, and in turn both oil companies and ranches use computer technology to streamline their operations.

From personal, economic, and environmental perspectives, the workplace, tools, products, and by-products of production offer compelling insights into the connections and tensions that characterize the transformation of the Texas socialscape.

Cowboys work directly on the land with living animals, both horses and cattle, that are dependent on natural resources such as clean water and healthy grasses. This responsibility establishes the cowboys as caretakers, not only of the stock but also of the land. It also tends to make their work unpredictable, nonrepetitive, and ecologically centered. Since the cowboys traditionally live on the ranch, they are available at all times for emergencies, but their work week is generally from dawn to dusk six days a week.

Roughnecks work on the same land as the cowboys, but the land itself is merely a platform for their rigs. The condition of the land is not significant to the drilling process. The work area has been scraped clean of trees and grass to the dirt. The area is leveled and a steel rig platform or deck is built some eight to twelve feet above the ground. Most of the work takes place on this platform or higher on the rig tower itself. Downtime is usually spent in the doghouse, a small, steel building attached to the deck. Once the drilling starts, the work of the roughneck tends to be fairly predictable, repetitive, and not dependent on ecological concerns or the weather. Most rigs run day and night, seven days a week.

Microcomputer technicians in the Austin area most often work in high-security fabrication laboratories, called fabs or clean rooms, that are sealed off from the rest of the building by buffer rooms where workers change from street clothes to

bunny-suits, the sterile, white nylon lab jumpsuits with hoods, nylon boots, goggles, surgeon's gloves, and beard, hair, and face masks. Most of these companies are located on the outskirts of Austin in areas that, less than twenty years ago, were pastures similar to those on the Green Ranch two hundred and fifty miles to the northwest. The fabs are designed with sophisticated filtration systems that continuously clean the air of foreign particles. Any remnant of the prairie is left outside because dust particles of virtually any size interfere with the conductance of the silicon wafers out of which computer chips are made.

Here, in contrast to the cowboys and the roughnecks, the microcomputer workers are removed from any direct contact with the land and its components. As it does for the roughnecks, the land functions primarily as a footprint location for the modern buildings characteristic of high-tech facilities. In contrast to both the cowboys and the roughnecks and as part of the transition from rural to urban landscape, high-tech workers come to work each day where the prairie has been transformed into a beautifully landscaped, parklike environment. Hiking and running trails often weave through the property. All is surrounded by large asphalt parking lots to accommodate the thousands of workers who keep the plants running twenty-four hours a day, seven days a week. The only semblance of the original prairie is the roll of the hills and the big Texas sky workers see as they walk from their cars into the building. The work performed by the technicians is, to a large extent, like that of a sophisticated assembly line, where the same tasks are repeated to build machines or manufacture computer chips or other parts. Thus, much of the work is predictable, repetitive, and clearly not dependent upon weather or ecological concerns.

The tools of the trade for the cowboys include horses, saddles and tack, ropes, spurs, chaps, large-brimmed hats, tall boots, branding irons, corrals, squeeze-shoots, tractors and implements, trucks, and irrigation systems, all of which are designed specifically to work on or with the land. Communication is usually person to person though computers, shortwave radios, and cell phones have become more prevalent. The main by-products that affect the land are manure and field stubble, both of which contribute to ecological cycles. In farming areas fertilizer and pesticides raise ecological concerns.

Roughnecks work with more mechanically oriented tools made mostly of steel. Thirty-foot sections of pipe weighing some two thousand pounds each are hoisted by massive lifts that run on steel cables inside the rig. Hard hats, steel-toed boots, sledge hammers, huge mechanical wrenches, long chains, and cables in constant motion fill the deck when pipe is being added or removed from the drilling hole. The tools are designed to operate and repair machines. Except for the drill bit that chips away at the subsurface strata and the pipe that runs down into the deep well, the tools used by the roughnecks have little to do with the land surface directly. Inside the doghouse a computer and printer keep track of depth and other pertinent drilling information. Computers and shortwave radios or cell phones provide communication with the headquarters, usually in town. The on-site by-products are mostly mud, bare ground, and sometimes fumes and odor from burning gas flares. After the drilling is complete, the site is leveled in preparation for the addition of a pump jack and oil storage tanks to the landscape.

Microcomputer technicians work with both mechanical and electrical technology tools, depending on what part of the assembly or production process they work on. Dressed in bunny-suits, those who do basic assembly work on machines use simple wrenches, screwdrivers, and pliers and work with computers, wiring, chemicals, and gases. Those who produce computer chips work with large, sophisticated etch systems and ion-implantation tools that are run by computer and use acids and arsenic, among other organic substances. Communication is person to person or by e-mail or phone, but social interaction is minimized on the assembly floor. All organic substances in the fab are contained in closed systems. The by-products of chip manufacture

Once-high prairie grasses have been shorn to stubble; tundra, tramped to sod, seeded by hoof and dung-dropped mesquite. Sod has been turned under horse-drawn steel-bladed plows, planted with fescue and coastal grazers, then tractor-mowed and bailed. Now it is mown to sweet, green Saint Augustine.

Saint Augustine rolls over prairie hills from highway to acres of asphalt parking—Saint Augustine, watered by remote, trimmed by hand. Grass, not hay, winds along cement paths through weedless, landscaped gardens to chrome and glass doors revolving endlessly in red-brick facades that rise above the landscape—modern architectural wonders, castles on the prairie.

Glass-eyed sentries note all who pass and report to remote monitors surveyed in glances by guards behind mahogany reception desks. This, the first defense against drifters and the onslaught of prairie dust, potential destroyers of sterile clean-room environs that reside deep in the labyrinth, where ultra-clean air is filtered and organic matter contained in stainless steel. Here white-robed engineers, face-masked, eye-goggled, with surgeon-gloved hands, tap keyboards transmitting electrical impulses to acid etchers and chrome-clad micro-cannons that implant arsenic ions one, two, three deep into chip-laden silicon wafers. Ion conductors of electronic symphonies hum sweet music on the frontier of technology.

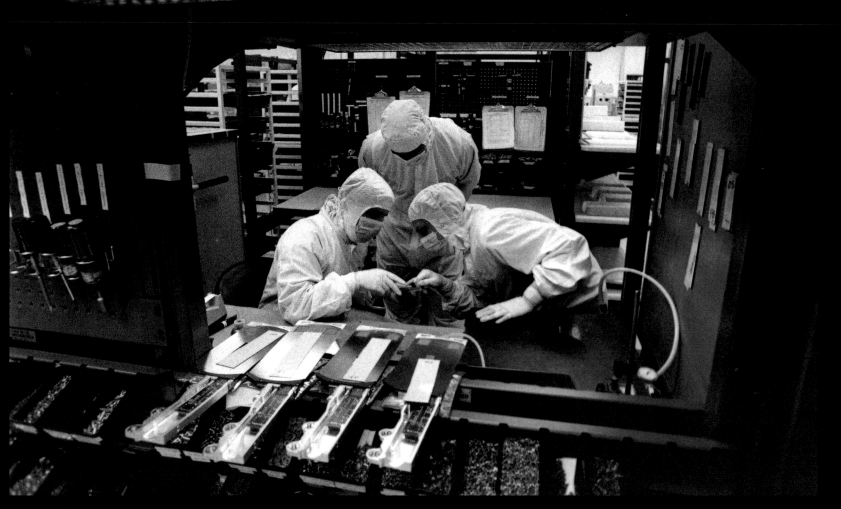

CONSULTATION 1996

are often highly caustic and corrosive materials that must be properly treated and disposed of to protect the ecosystem.

Economic characteristics of the groups show a transition from those associated with developing and nurturing a small, trained, valued workforce to those needed to develop a vast pool of technical resources in workers who, at the lower levels, are hired and laid off according to seasonal production and economic fluctuations. On the ranch, housing, food, medical expenses, and job security are often provided to cowboys who live with their work; in oil and high-tech industries, benefits take the form of higher salaries, inexpensive medical packages, and sometimes stock options and bonuses—but with less job security. This transition reflects a social and economic transition within Texas from family-oriented, fairly secure, rural agribusiness, where cowboys work together, often for many years, to a corporate culture based primarily on the bottom lines of multinational companies operating more and more tenuously in a growing global economy. As evidenced by mass layoffs in the U.S. high-tech industries during the Asian economic crisis of 1998, this multinational structure reflects the emergence of a new type of economic interdependence.

Overall then, as we move from the agrarian to the technological, we move away from a direct, caretaker relationship with the land and ecosystem, to a system that is basically neutral in its direct, exploitive relationship with the land, to a high-tech system that shuts out the land and then refines caustic manufacturing materials before returning them to the ecosystem. We move from tools that are designed to work with and on the land and with animals, to tools that are primarily mechanical and designed to operate on top of the land harvesting crude oil from deep subterranean pools, to more sophisticated mechanical tools and computer-driven, electronically controlled manufacturing tools and robots that manipulate acids and arsenic ions to create microcomputer circuits within the various layers of silicon wafers.

Sociologically, we move from a nontransient, family-oriented business where cowboys live on the ranches where they work, often with their families, to a more transient, competitive, and upwardly mobile work force in oil and technology. The exclusion of women and the assignment of minorities to menial labor jobs in the ranch and oil workforces gives way to integration of both women and minorities on all levels in the technological workforce.

Economically, the transition generates a change from a culture based on relatively small, independently owned agribusinesses, to larger energy corporations prominent nationally or even internationally, to multinational corporations and conglomerates that affect global economies and shape cultures through powerful influences on technology, communication, and political agendas. These connections and contradictions reveal some of the basic tensions in the struggle to balance the transition from an agrarian to a mechanical to a technologically centered socioeconomic structure in Texas and beyond.

For example, high-tech innovations continue to transform our systems of communication, education, and commerce at an unprecedented pace. As e-commerce breaks down physical and social barriers, high-tech communities such as Austin, San Francisco, Seoul, and Tokyo become the centers of global commerce and economic power. This structure generates both new physical communities among members of the vast company work forces and virtual communities via the internet and evolving new-media communication technologies. As greater numbers of workers opt to adopt the new trend to move from the physical community of the work place to home offices, many of one's new colleagues or friends may be known only in cyberspace. Community becomes defined by economic and informational needs rather than proximity and personal relationships. This reorganization of community has the potential to transcend and supplant traditional geographical and ideological allegiances that have served as the basis for community relationships, values, and identity for most of our history.

Thus, understanding the significance of these connections and contradictions in the transition from a rural, agrarian to an urban-based, technological culture is critical on levels beyond the Texas plains—on national levels, on global levels—to our interdependence and to the future of both local and global communities.

This challenge to understand, assess, and direct these individual and cultural transformations is significant and difficult. Because of the intense competition for both jobs and production quotas, the unprecedented pace and scope initiate rapid and far-reaching changes in the social structure, without providing time or incentive to consider either the alternatives or the long-term consequences. Most citizens have little access to, much less influence on, these culture shaping processes. The transformation is significant because it challenges all that has come before, right down to the foundations of Texas values, traditions, and culture. It is significant because it affects not only the rural landscape but also the larger community, which has traditionally drawn its sense of history and its sense of a broader perspective on human relationships from its heritage of rural community values, lifestyles, and traditions.

The question is not one of whether to change; it is a question of how to change. What will drive changes? How will change be implemented and evaluated? Who will benefit? Will change introduce new and valuable economic and social options that benefit individuals as well as local and global cultures? Or will change be made for economic reasons alone?

There are also the issues of learning from one's past, of remembering who one is and where one came from, of knowing what is expected, of placing quality above quantity. Native American wisdom suggests that decisions should be based on whether or not they serve the community for seven generations. Perhaps the most significant question today asks which of those values and traditions that have formed and guided the basis of this culture are worth passing on to posterity. How do we still the wheels of "progress" long enough to evaluate and direct change in order to assure a balance between the quantity and quality of our lives in this community of wondrous hostilities?

These are only some of the connections and dynamic tensions suggested by these images of cowboys, roughnecks, and clean-room technicians. In them can be found a diverse, even immeasurable array of cultural and personal meanings. For me, they represent above all a struggle to balance personal, ecological, social, and economic concerns in the transition from an agrarian to a mechanical to a technological economic base as it transforms the Texas socialscape and the daily lives of Texans.

The symbolic nature of the images works on several levels. Interpersonally, the images are representations of real people working in real time; they are also archetypal symbols of Texas myths and traditions. On an intrapersonal level the images are reflections of the artist's inner voice emerging, seeking the balance between power and grace. It is the realness of the people, of the contact, of the integration of our lives and our knowings that sustains the imagery as representational, archetypal, and intrapersonally symbolic.

Within each image, the more or less realistic representations of the interactions of people, their lifestyles, and their socialscapes exist in a symbiotic relationship with the cultural symbolism and metaphorical suggestions of the Texas mystique and with the emergence of personal insights and transformations. The organization of the images, both within their individual frames and within this book as a whole, attempts to integrate the realistic and representational with cultural and intra-personal symbolism. I hope the organization and content of the images and words suggest that the balance of grace and power in the individual guides the struggle to achieve balance within interpersonal relationships, which in turn, shape the inter-cultural relationships that connect us all across these vast prairies and beyond.

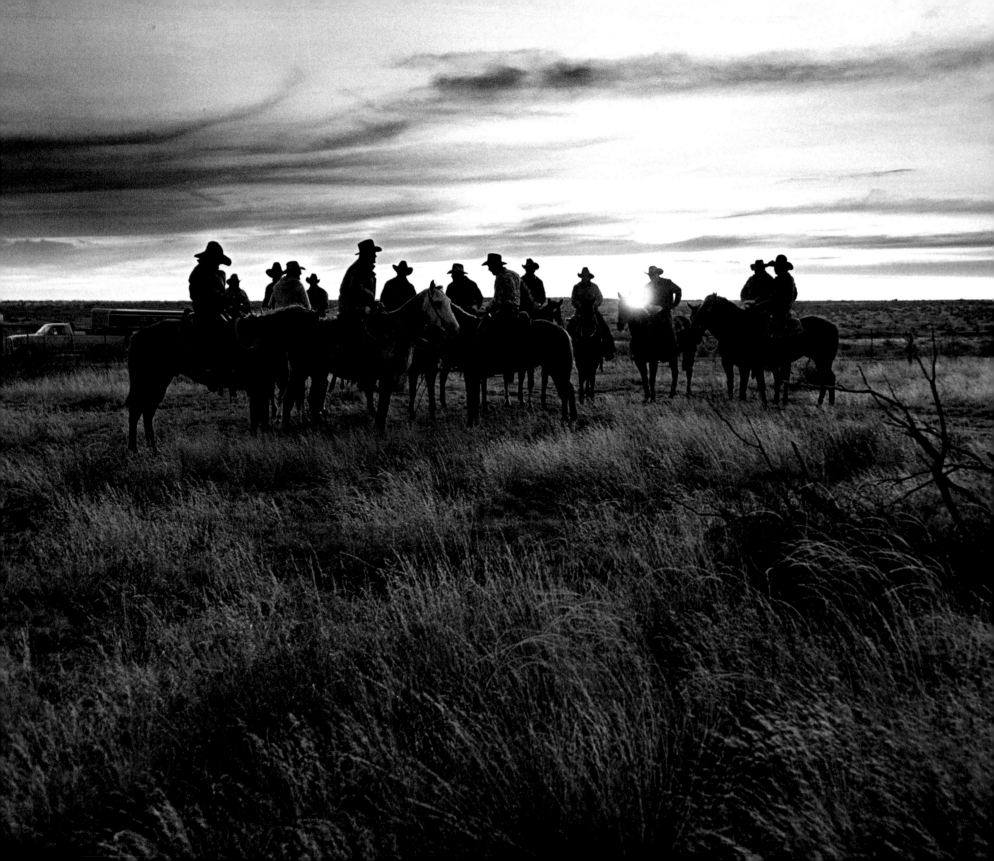

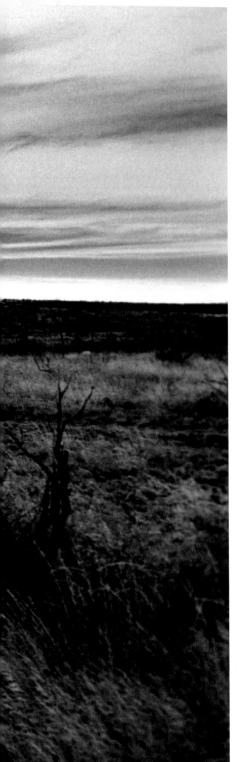

31

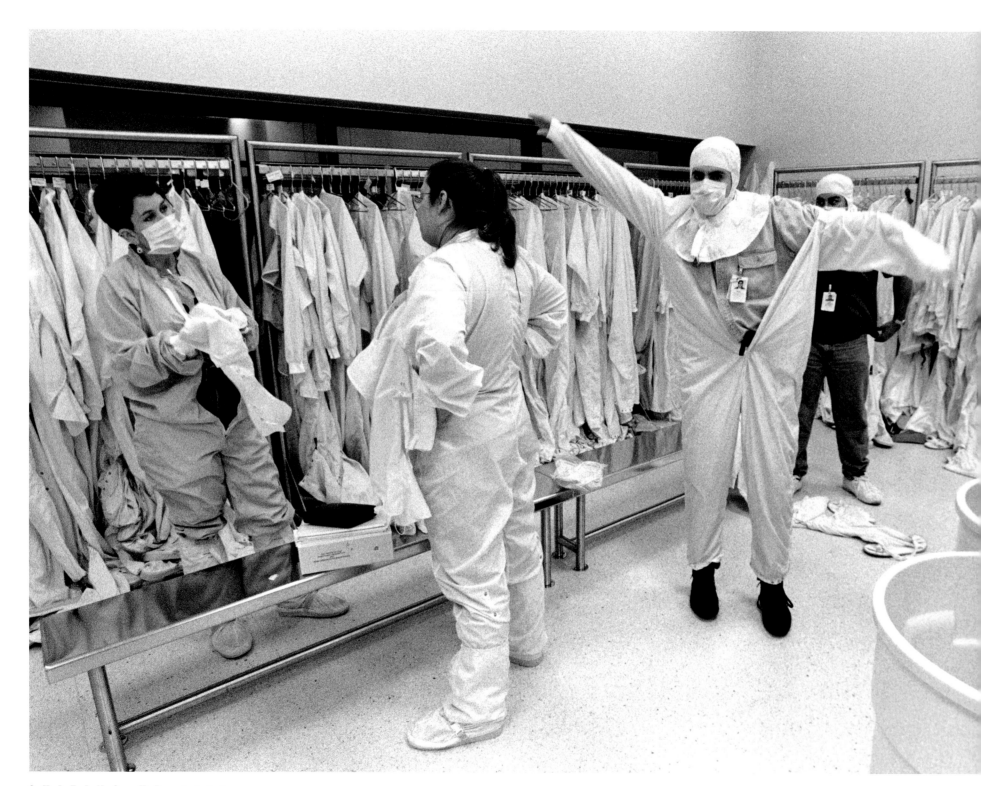

SUITING UP 1995

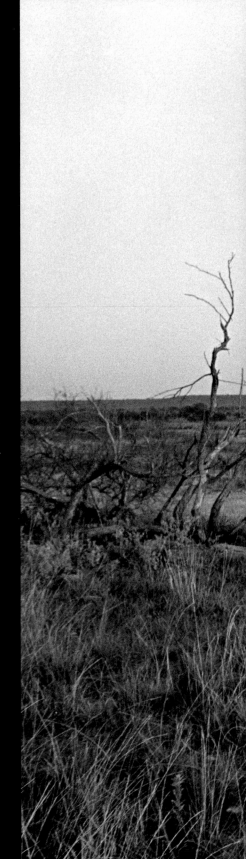

EARLY MORNING RIG, JONES'S RIG #51 1982

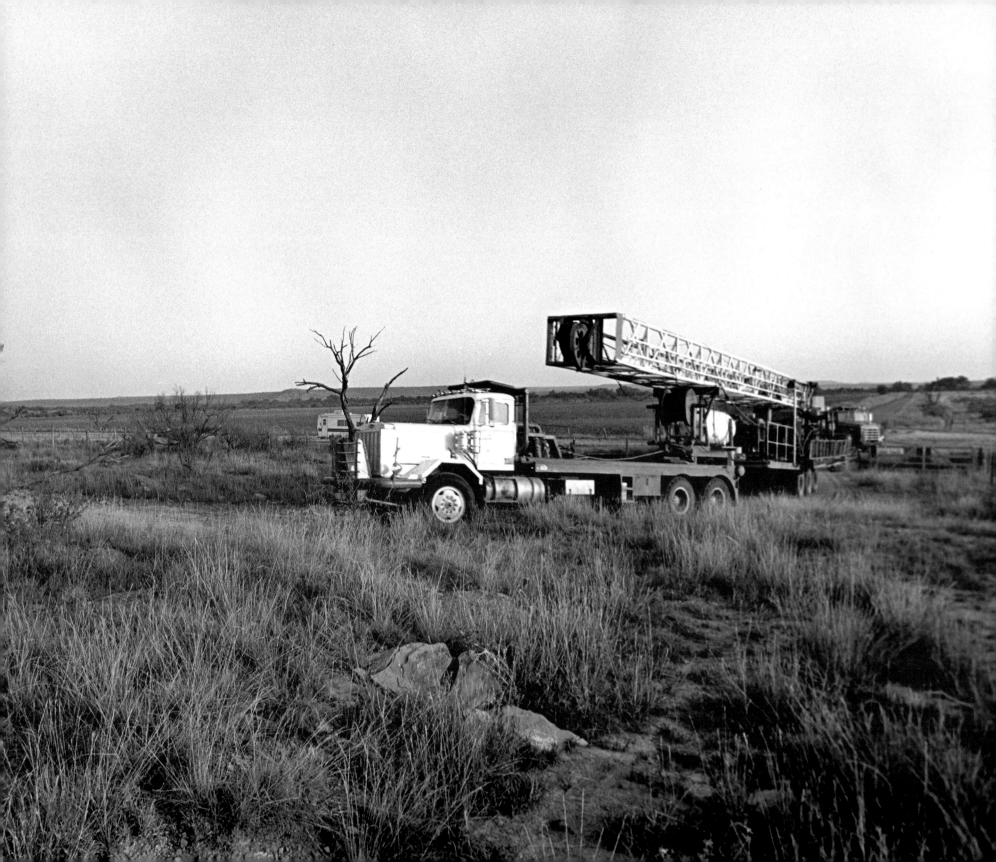

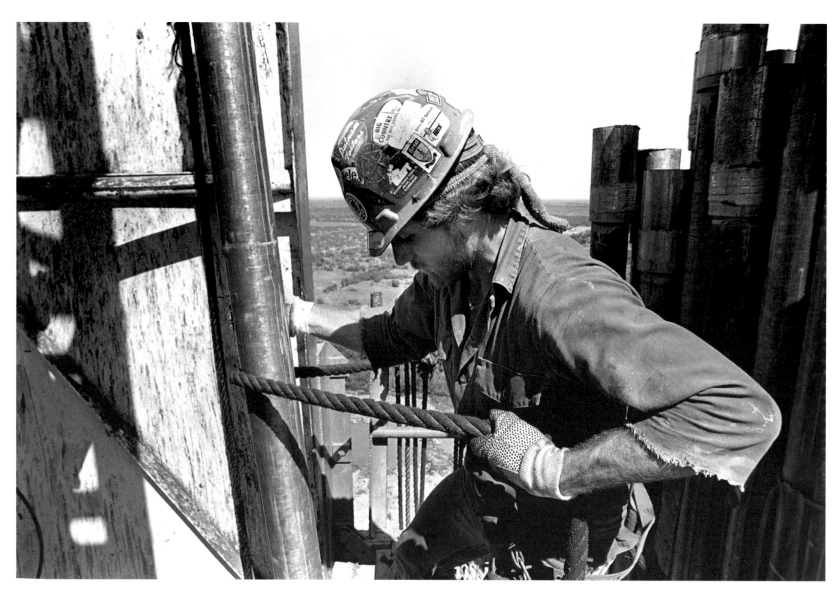

ROPE ON PIPE 1982

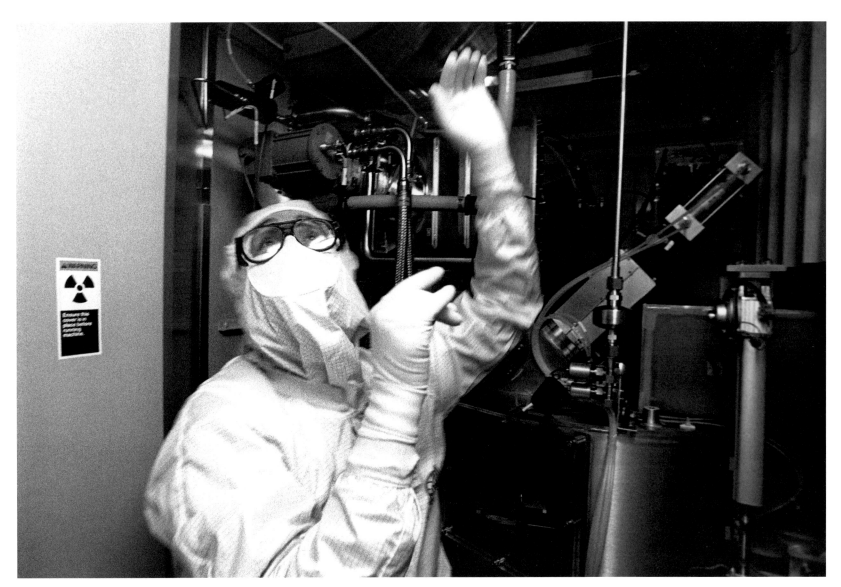

ATOMIC DANCE 1 9 9 6

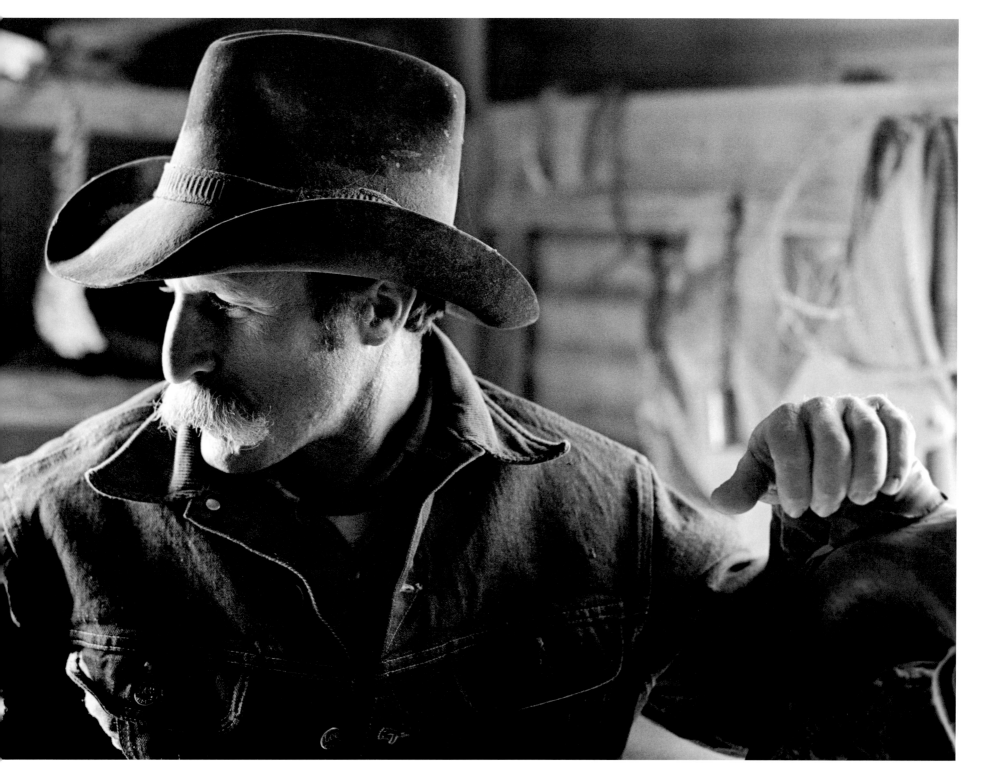

RON AT LAMBSHEAD 1981

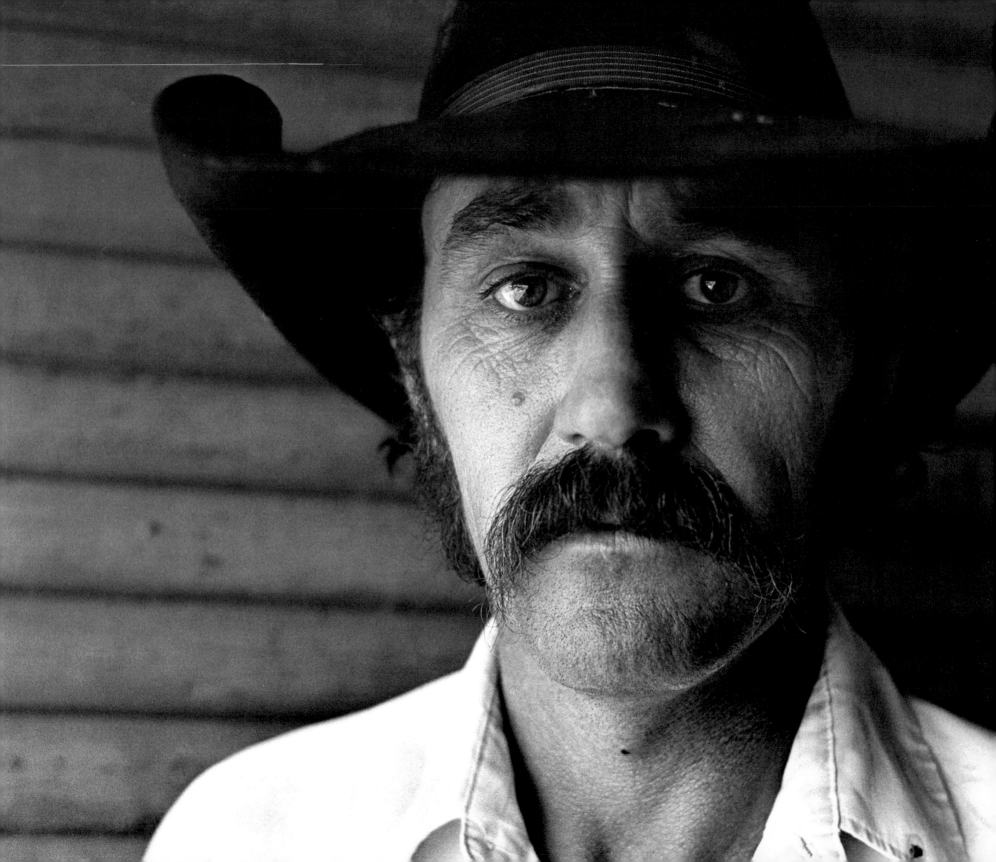

BENNIE PEACOCK, FOREMAN, GREEN RANCH 1984

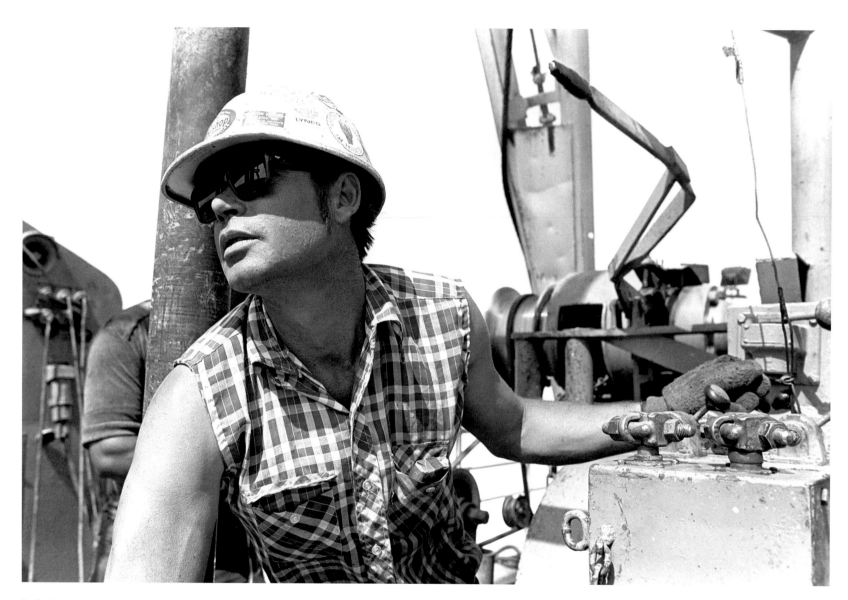

42

DRILLER 1982

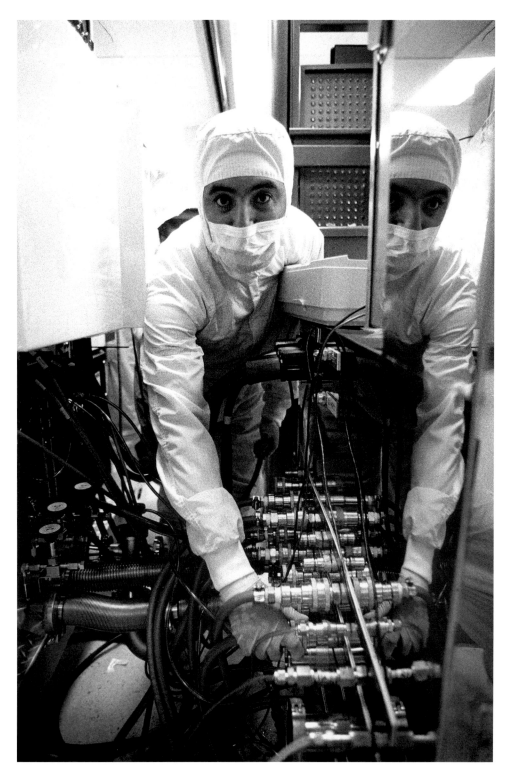

REFLECTIONS 1995

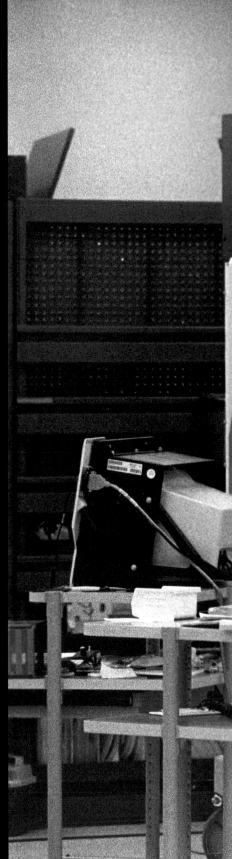

44

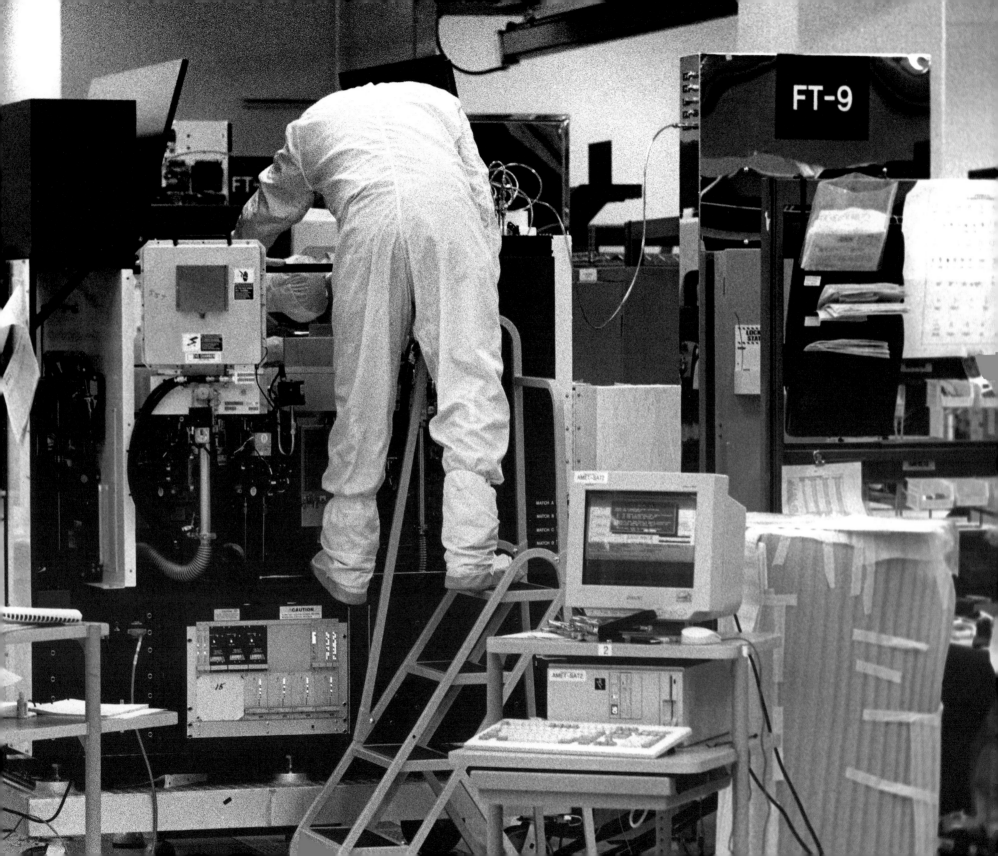

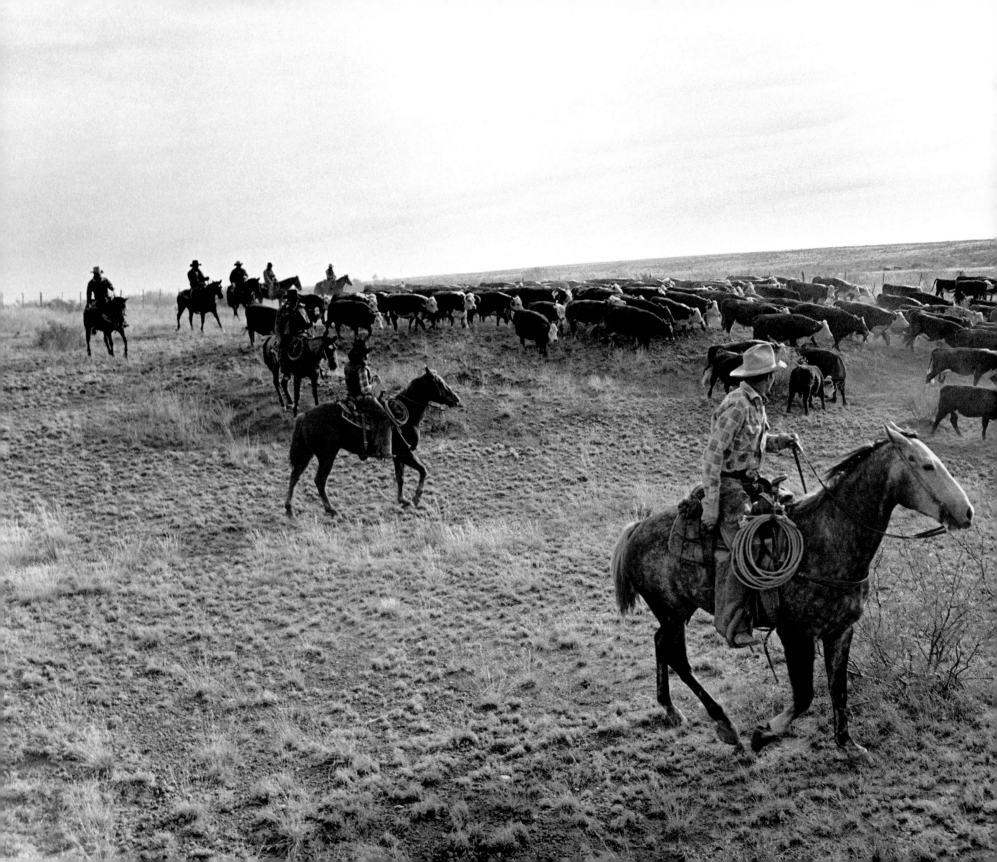

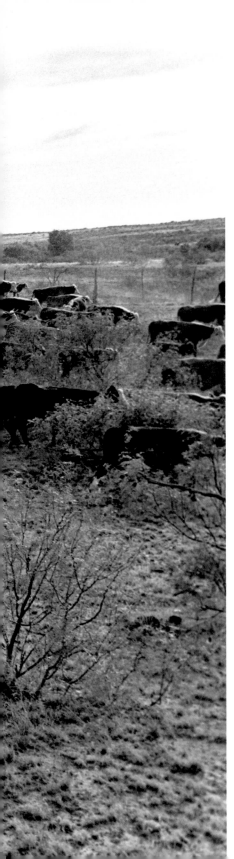

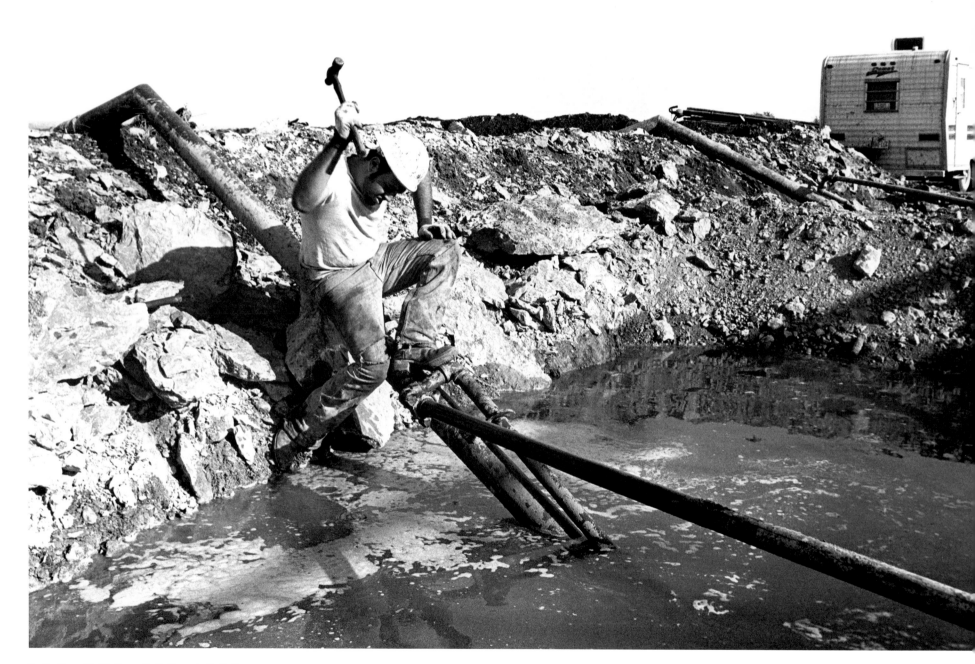

THE MUD PIT 1982

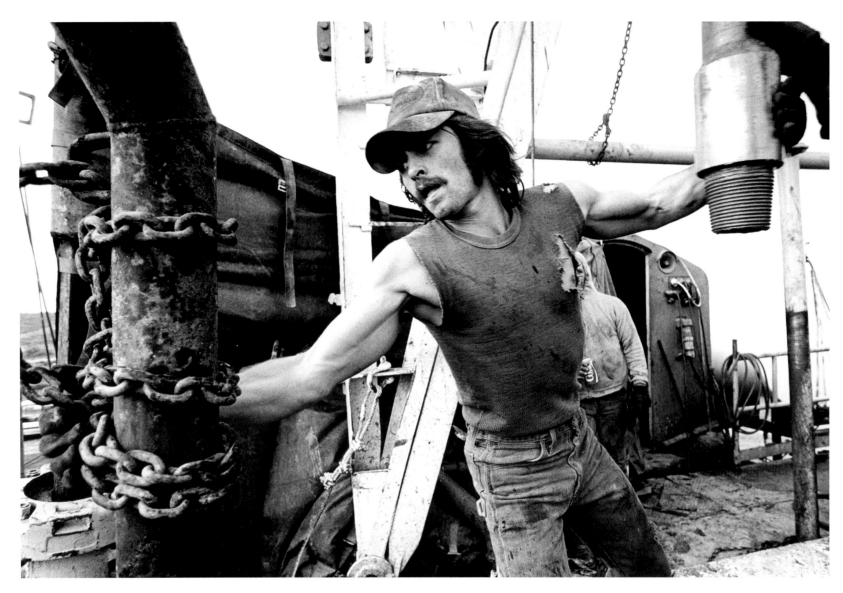

50

COMING OUT OF THE HOLE 1985

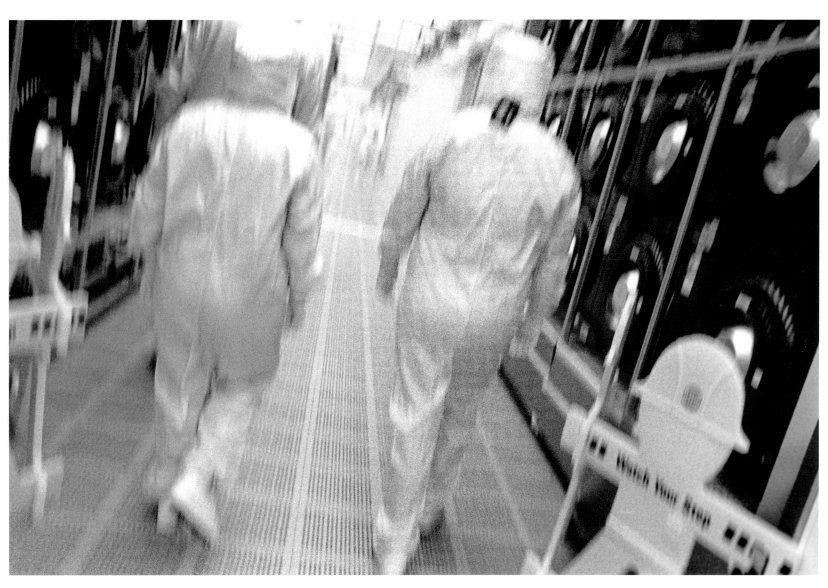

FAN WALK, ADVANCED MICRO DEVICES 1996

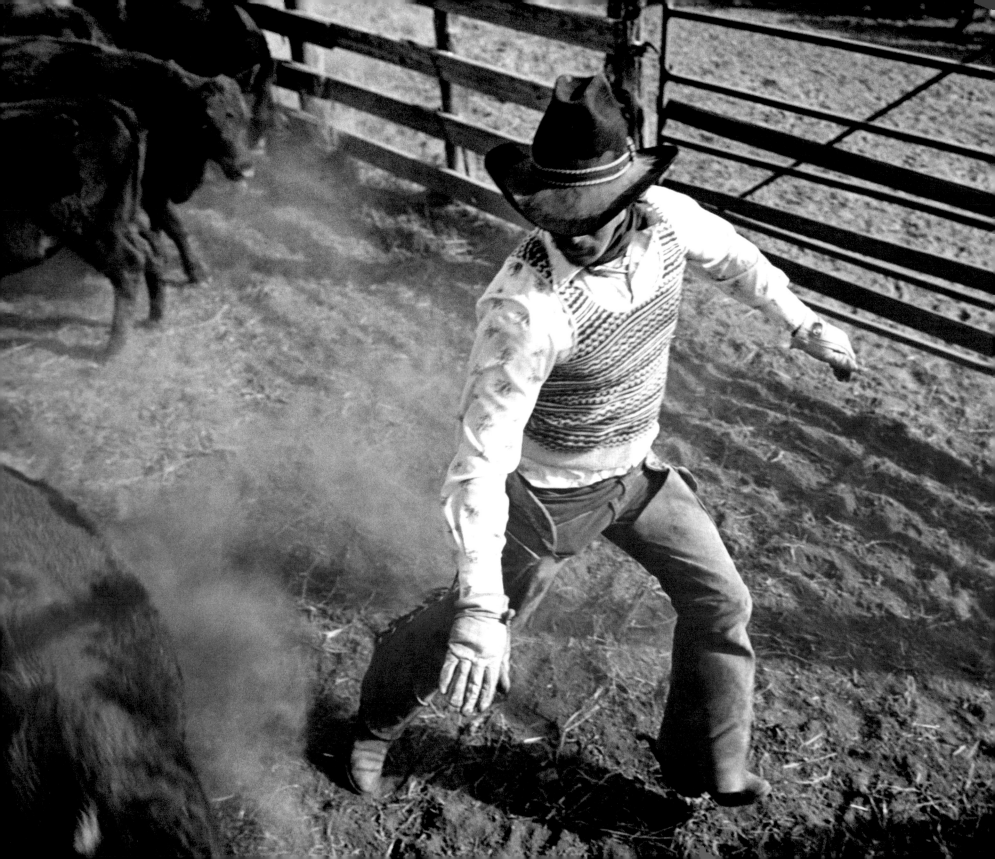

53

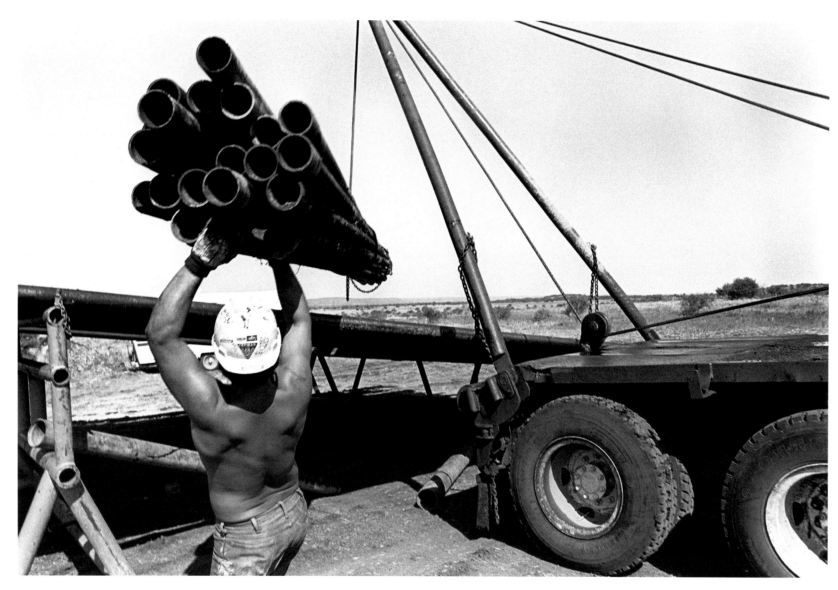

UNLOADING DRILLING PIPE 1984

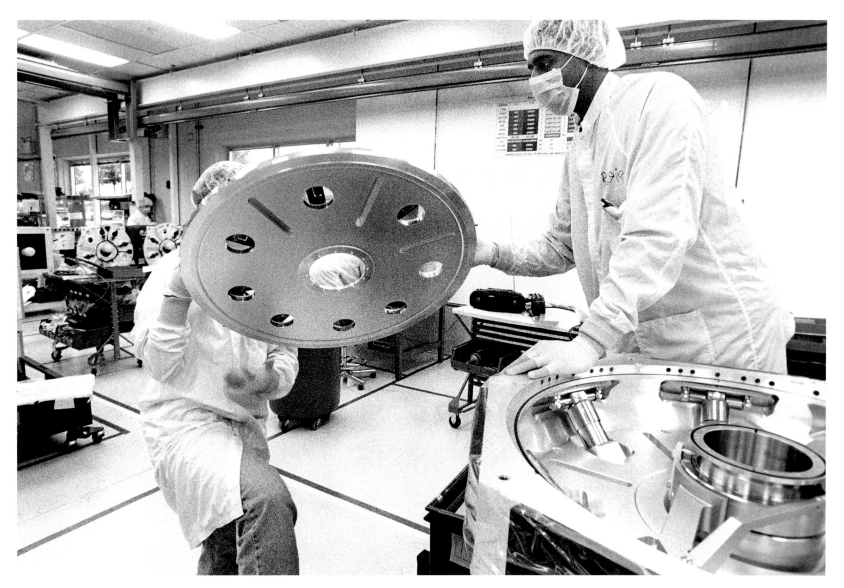

LOADING CHAMBER LID, APPLIED MATERIALS 1996

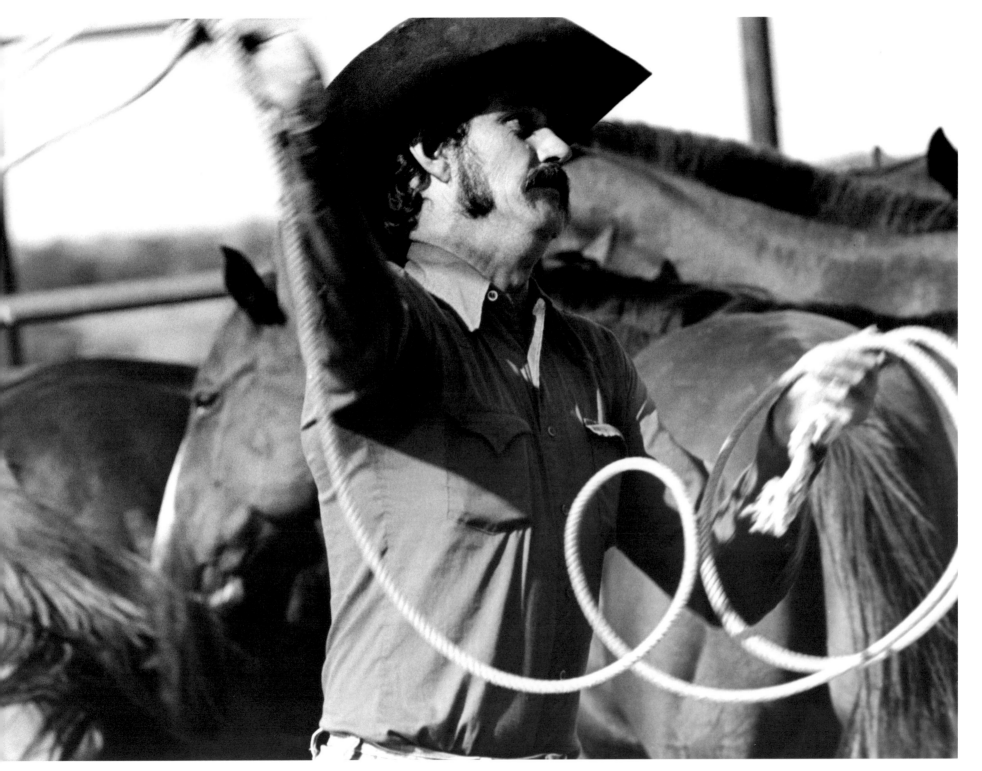

BENNIE ROPING 1981

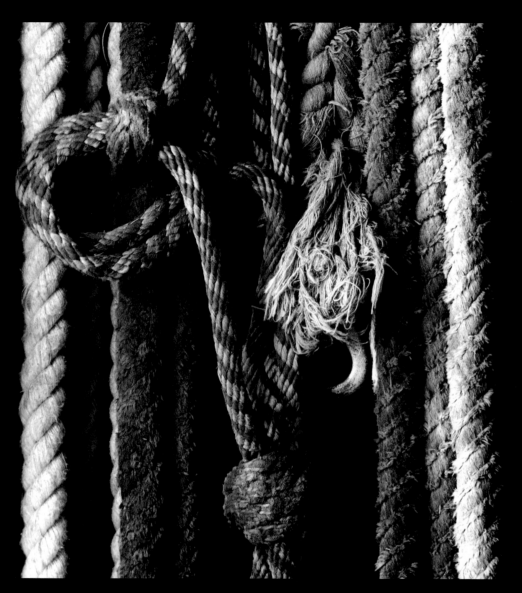

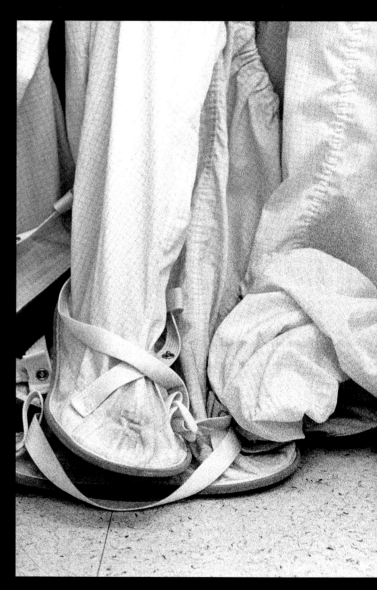

HACKAMORE 1981

RESTING FEET 1995

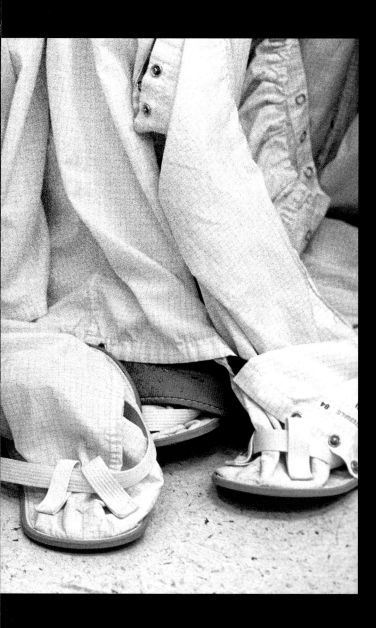

STANDING PIPE 1981

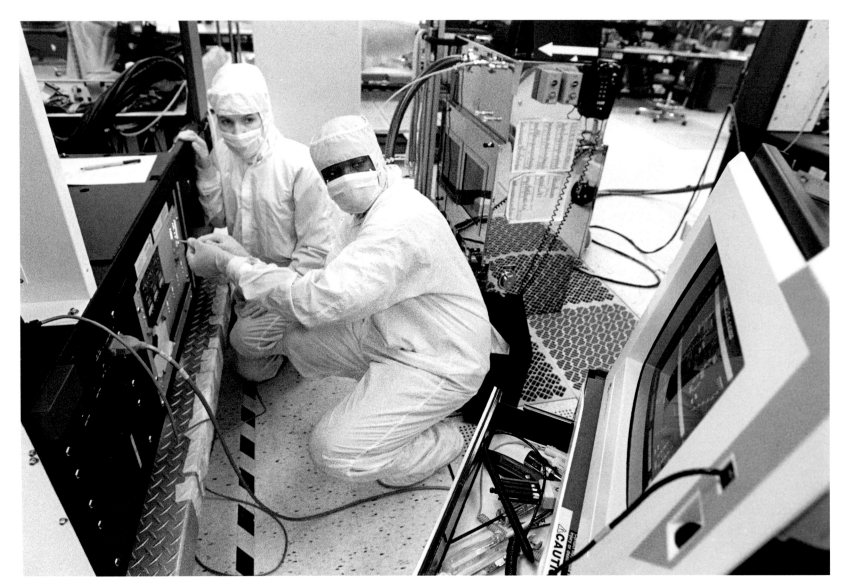

TESTING 1994

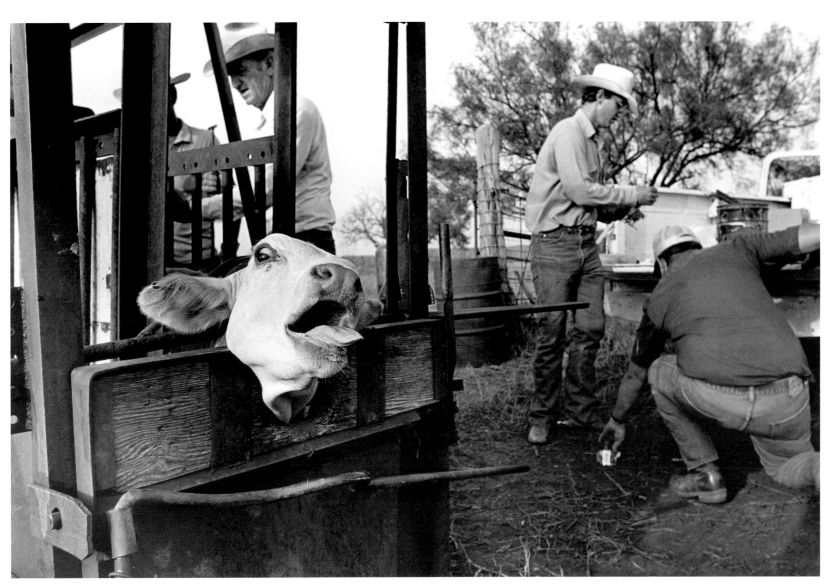

B R A N D E D 1 9 8 2

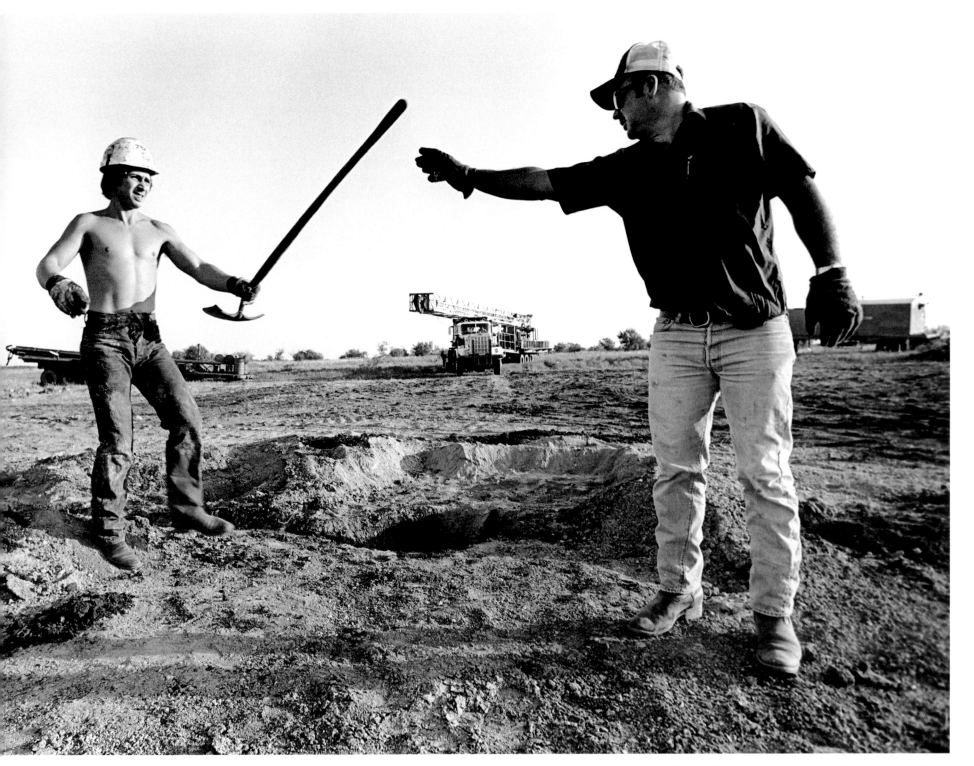

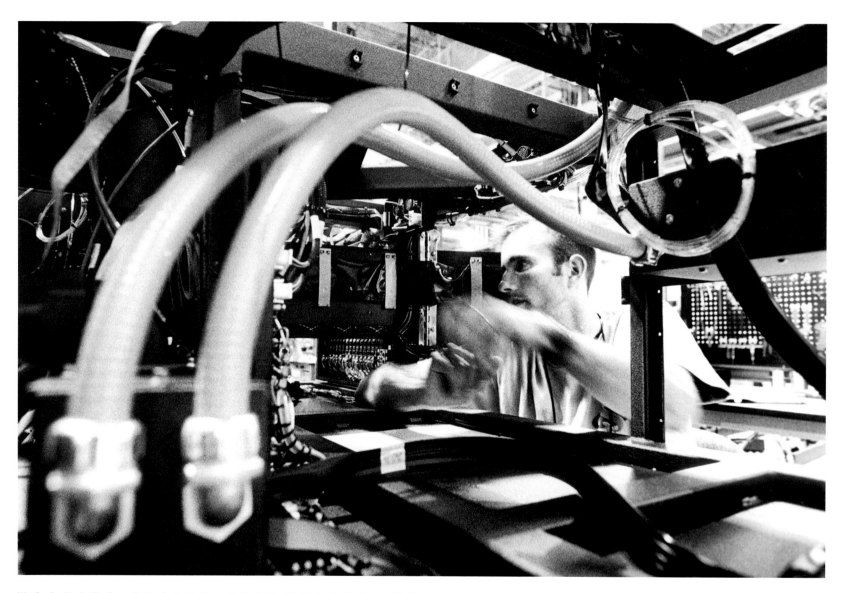

WORKING INSIDE TECHNOLOGY 1996

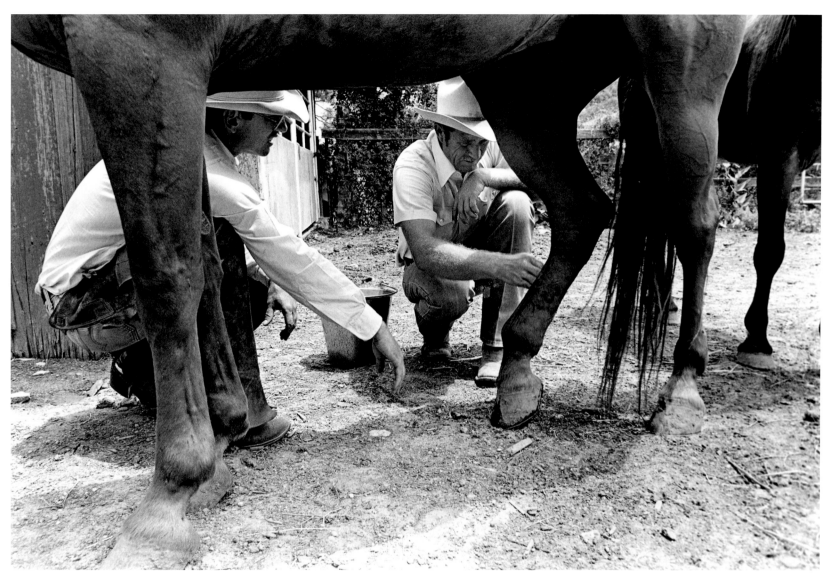

BILLY GREEN AND DOC TENDING A LEG WOUND 1982

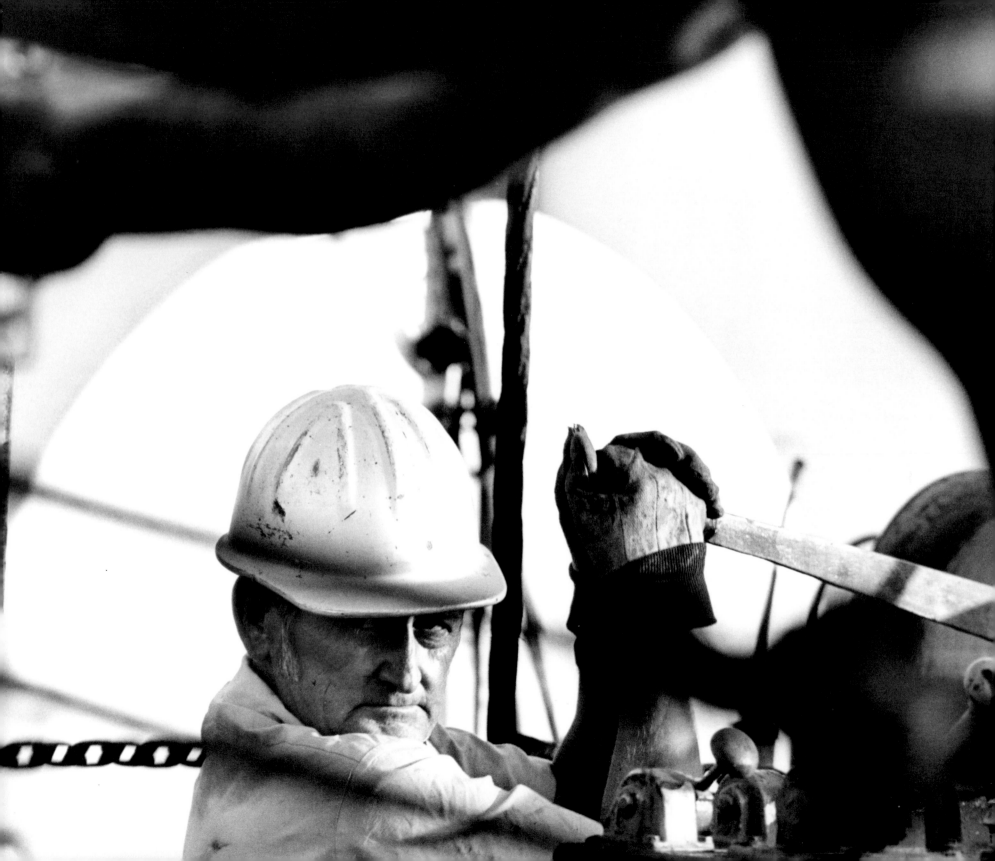

DRILLER ON THE THROTTLE 1985

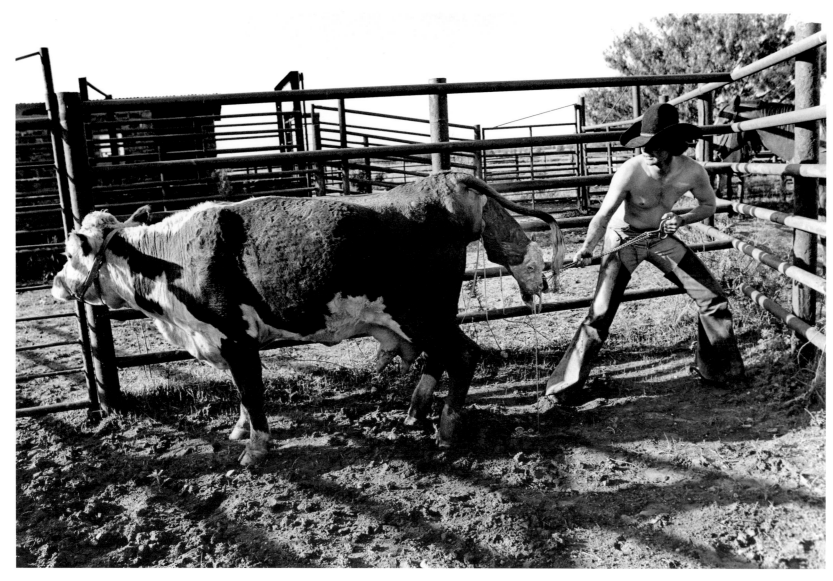

PULLING A CALF 1981

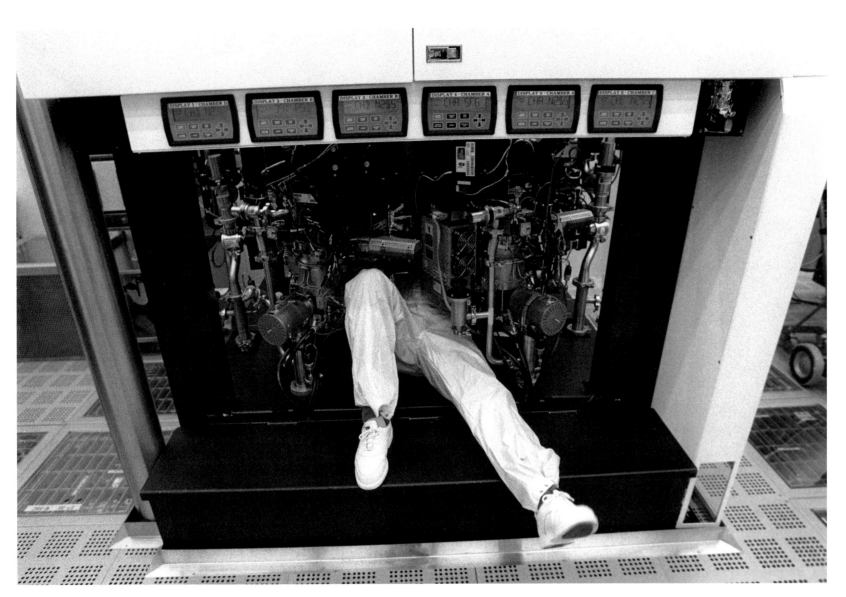

MECHANICAL REPAIR 1 9 9 6

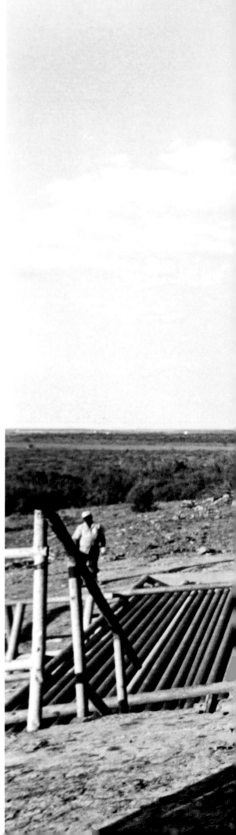

JUST MID-DAY 1 9 8 4

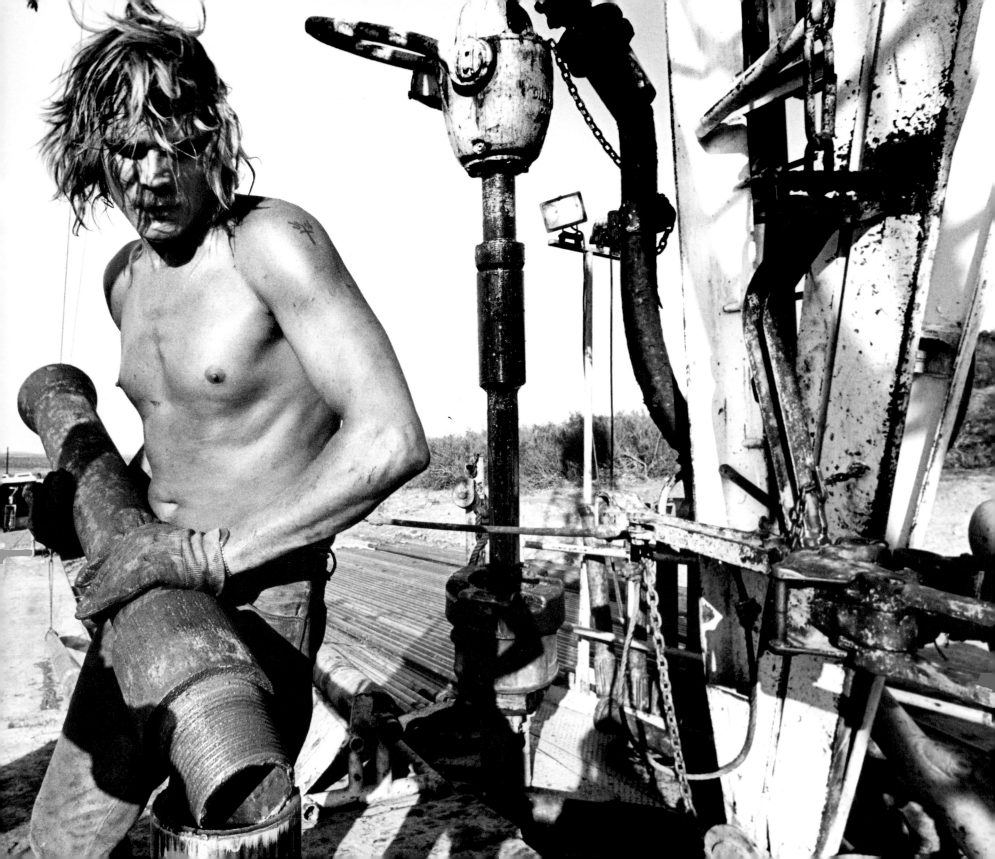

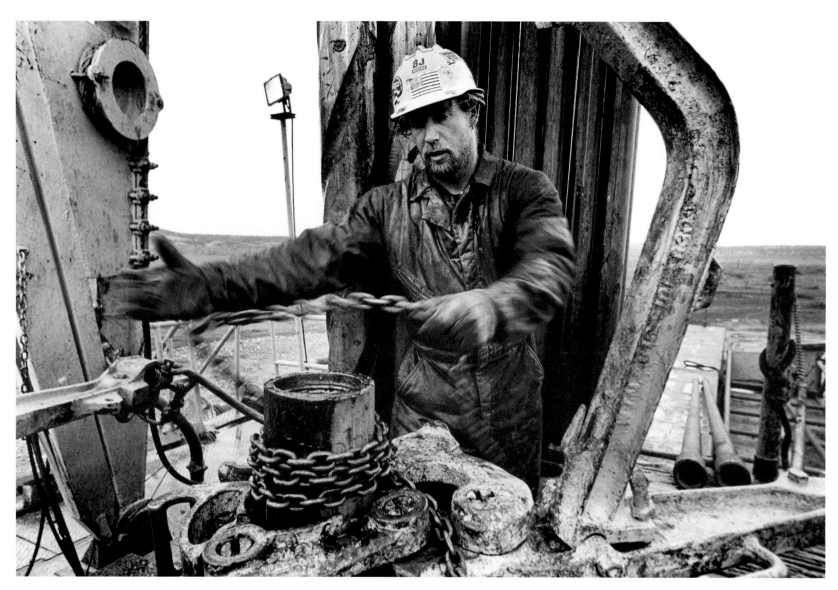

THROWING CHAIN 1985

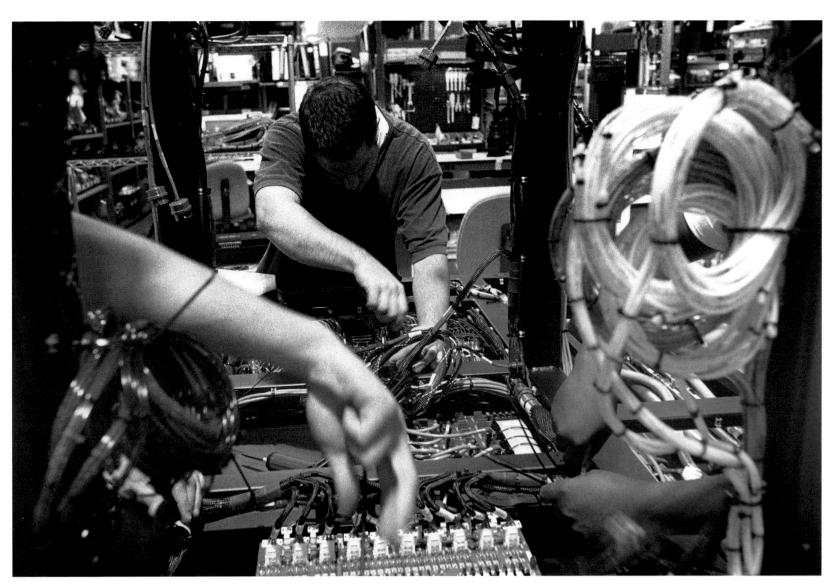

HIGH-TECH HANDS 1996

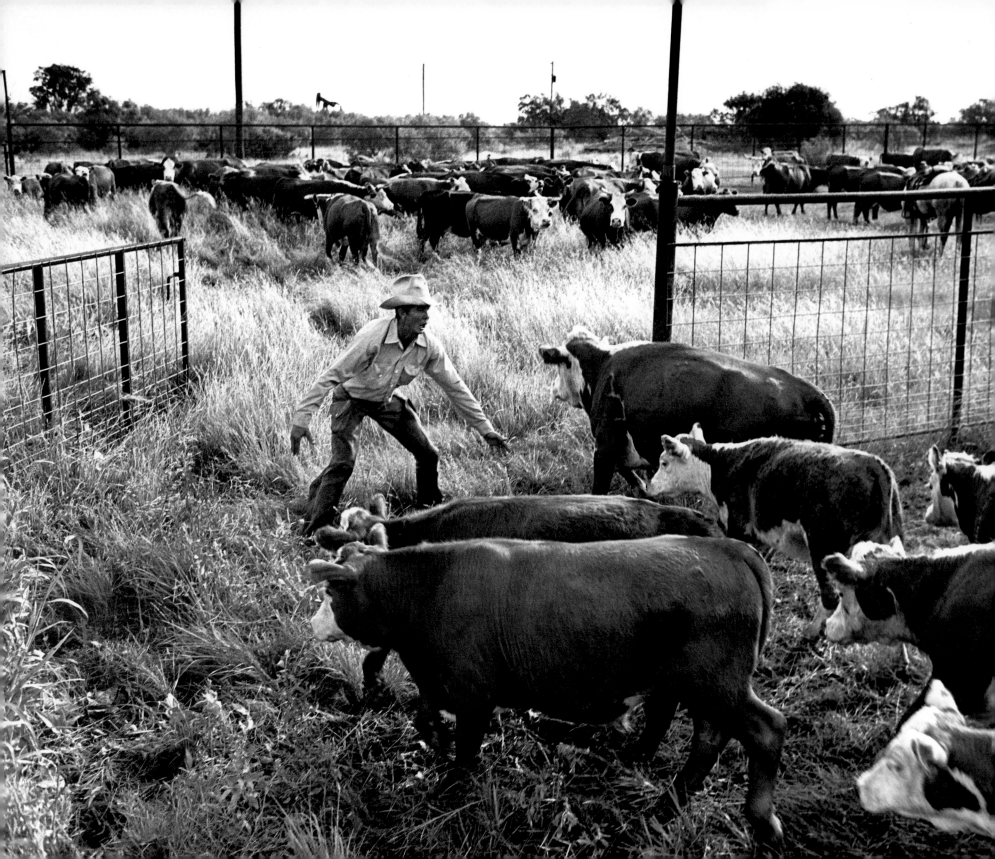

CULLING CALVES 1982

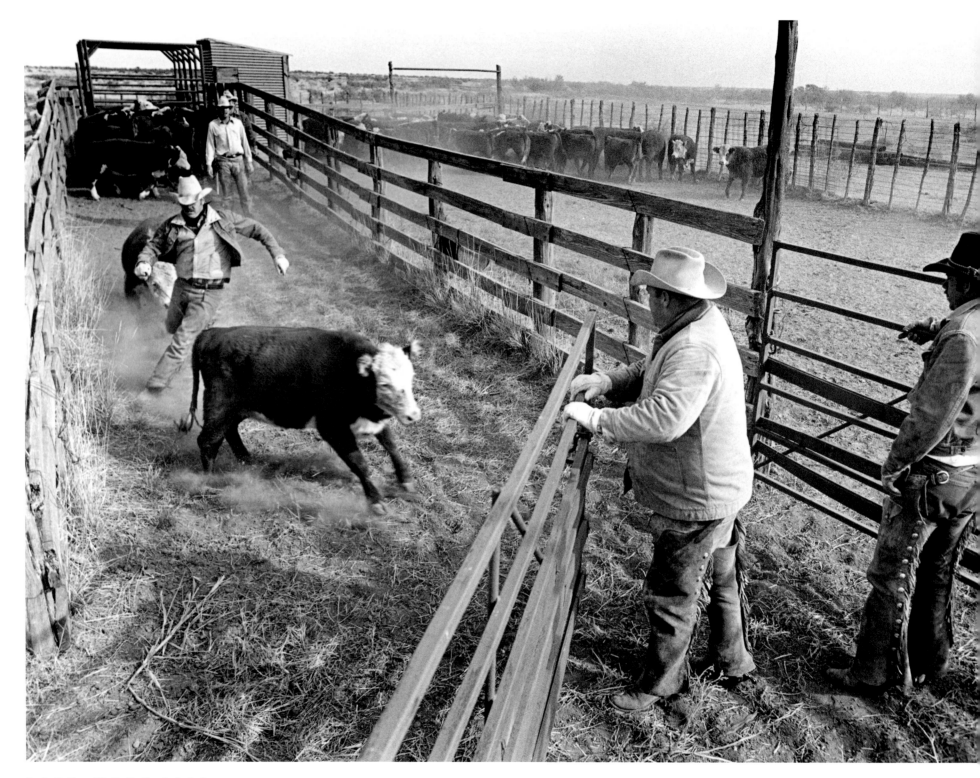

GATE WORK 1987

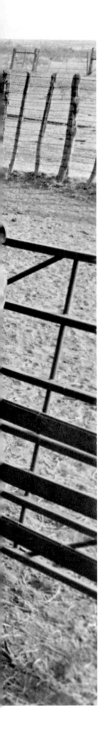

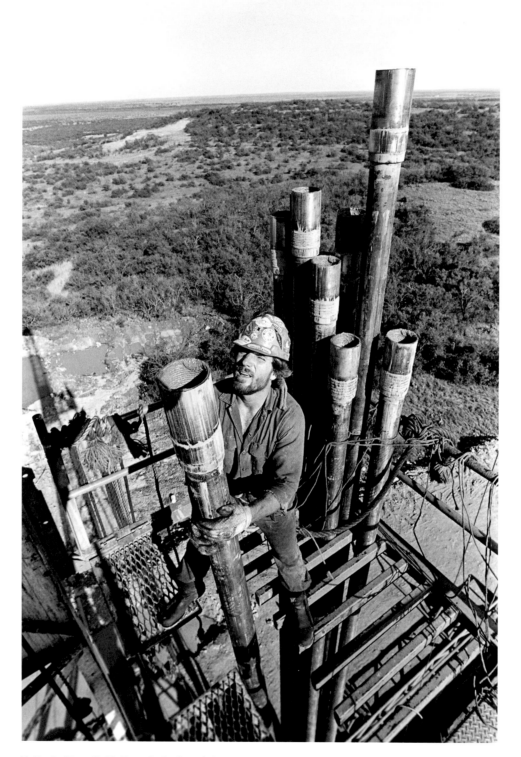

FROM THE CROW'S NEST 1982

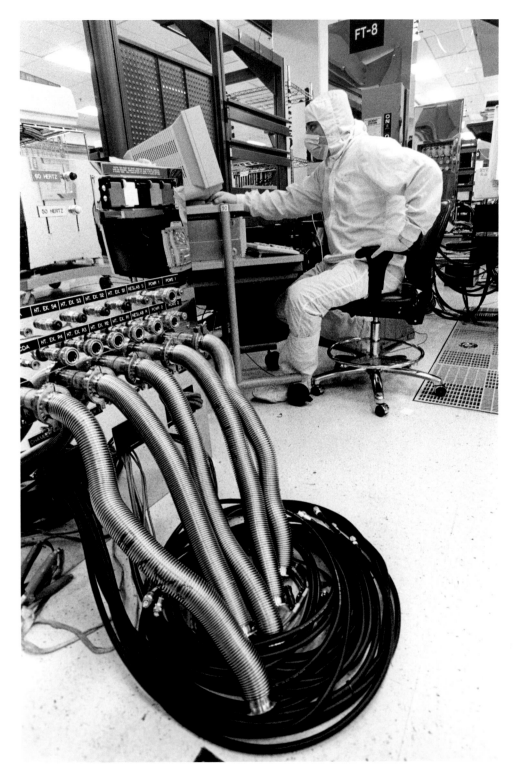

SNAKES 1995

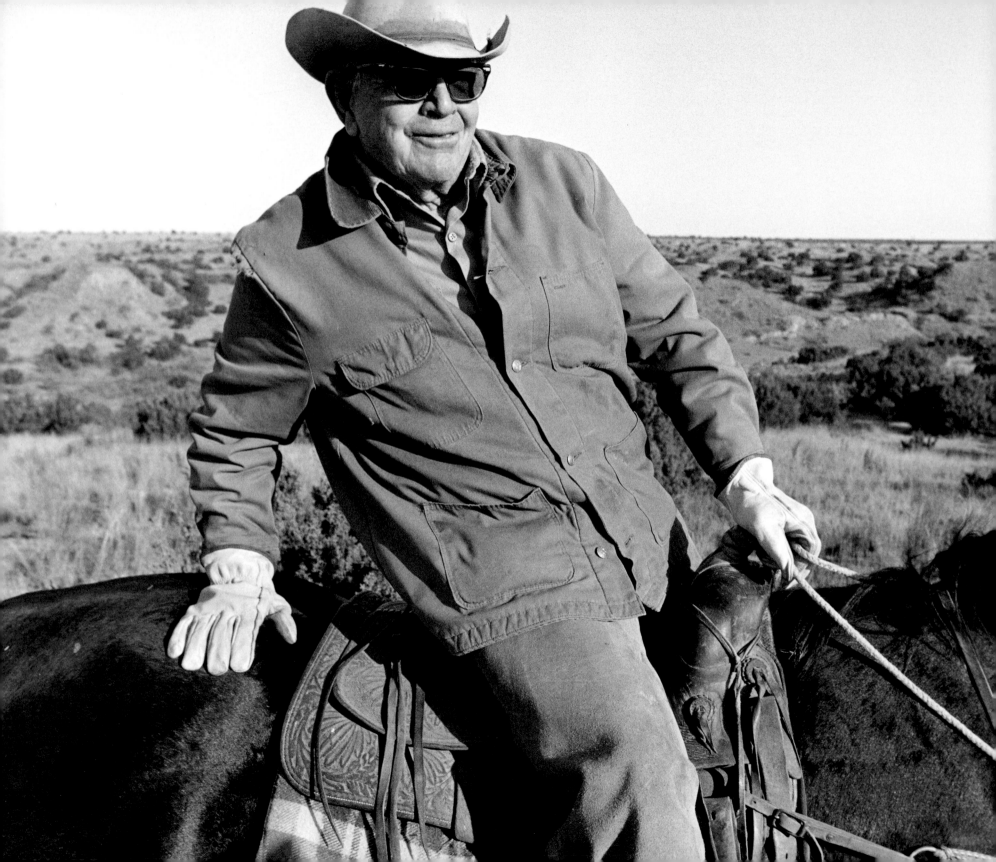

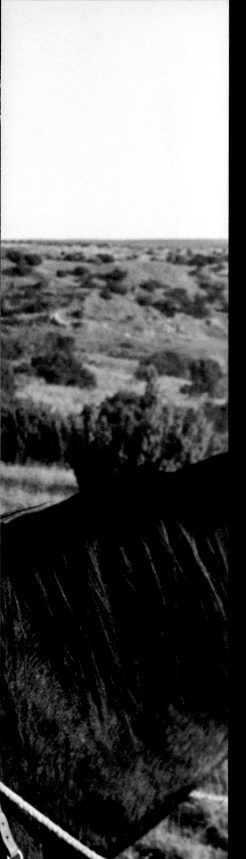

81

JOHN THOMPSON, MATADOR RANCH 1982

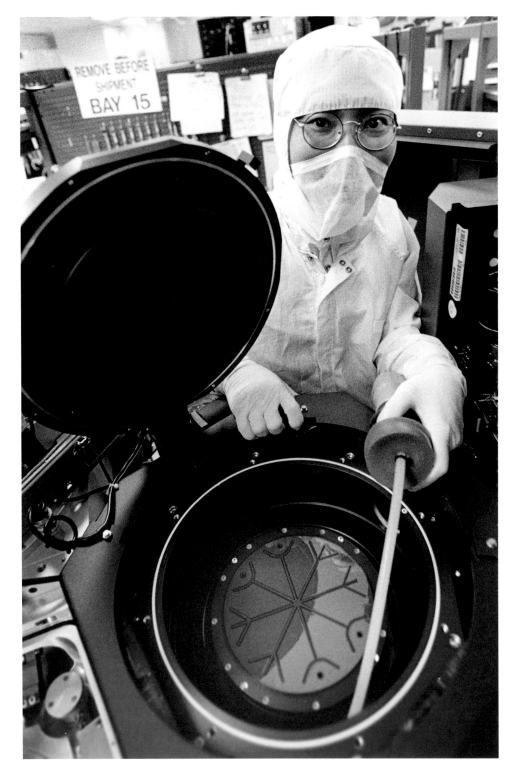

ANCIENT SYMBOLS 1995

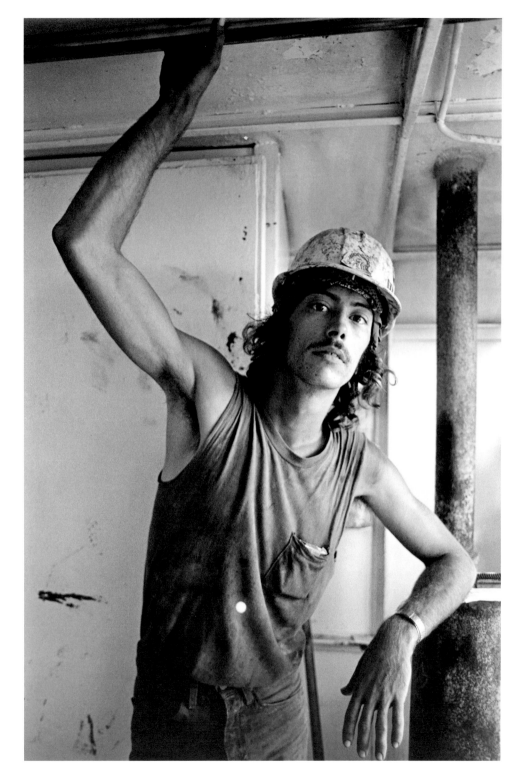

83

IN THE DOGHOUSE 1984

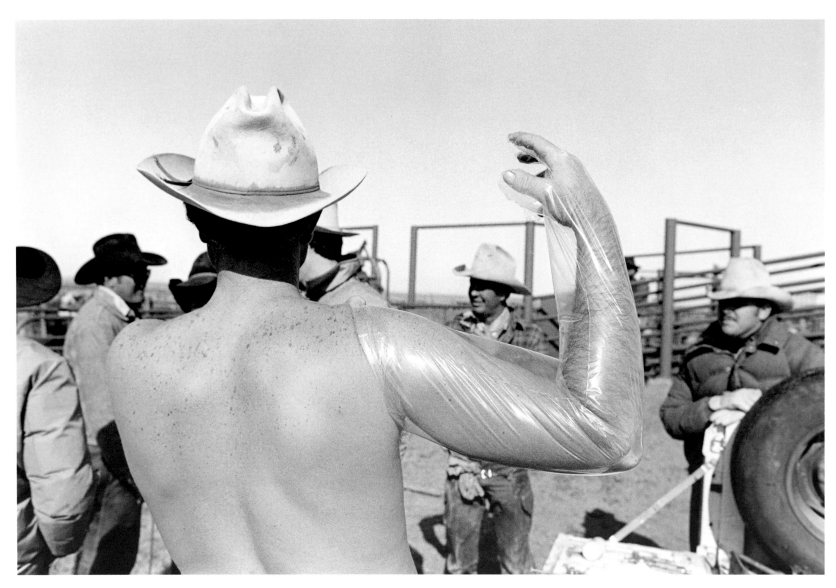

84

PREGNANCY TEST 1982

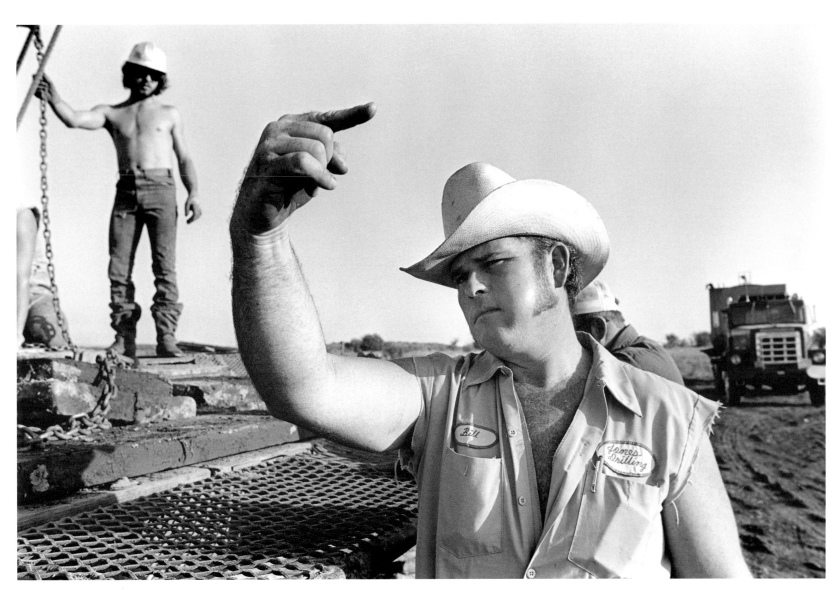

SETTING THE RIG 1982

HAND ON THE CIRCLE 1995

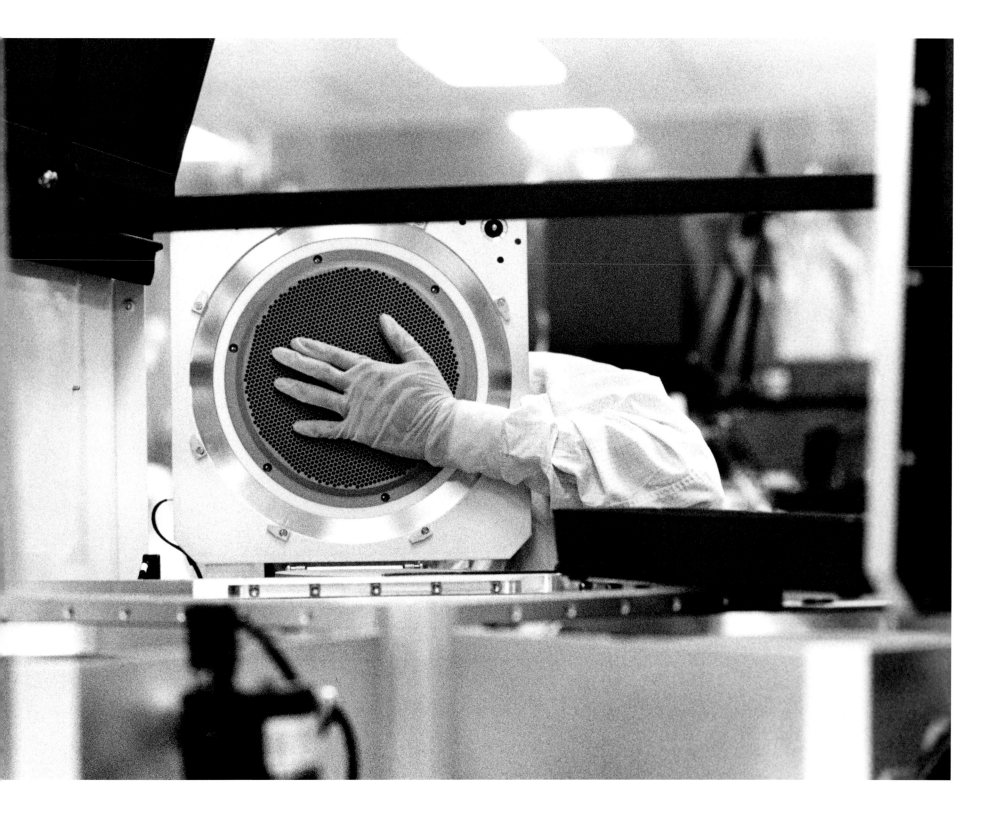

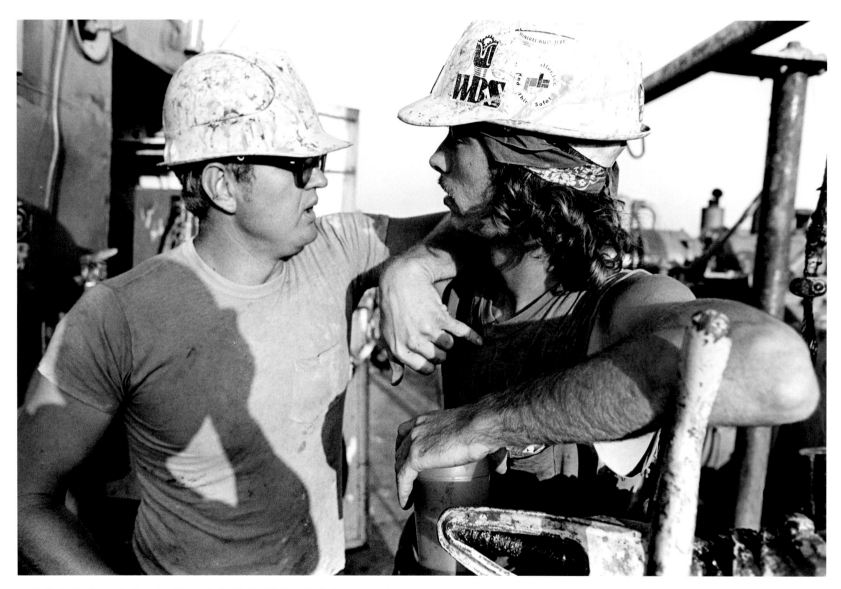

CONVERSATION, JONES'S RIG 1984

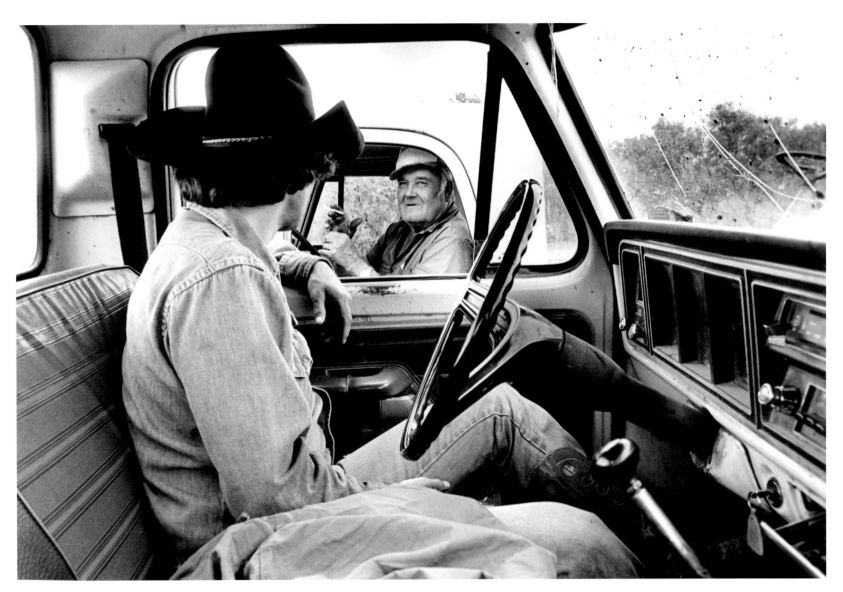

ROAD TALK, GREEN RANCH 1981

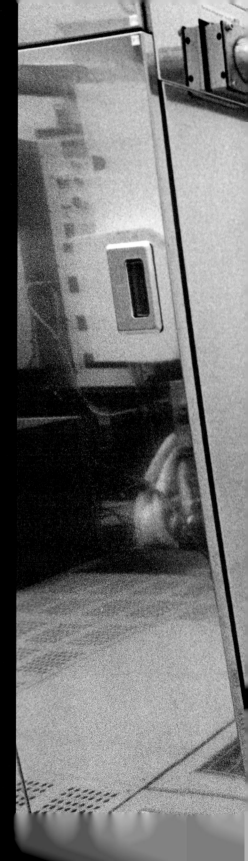

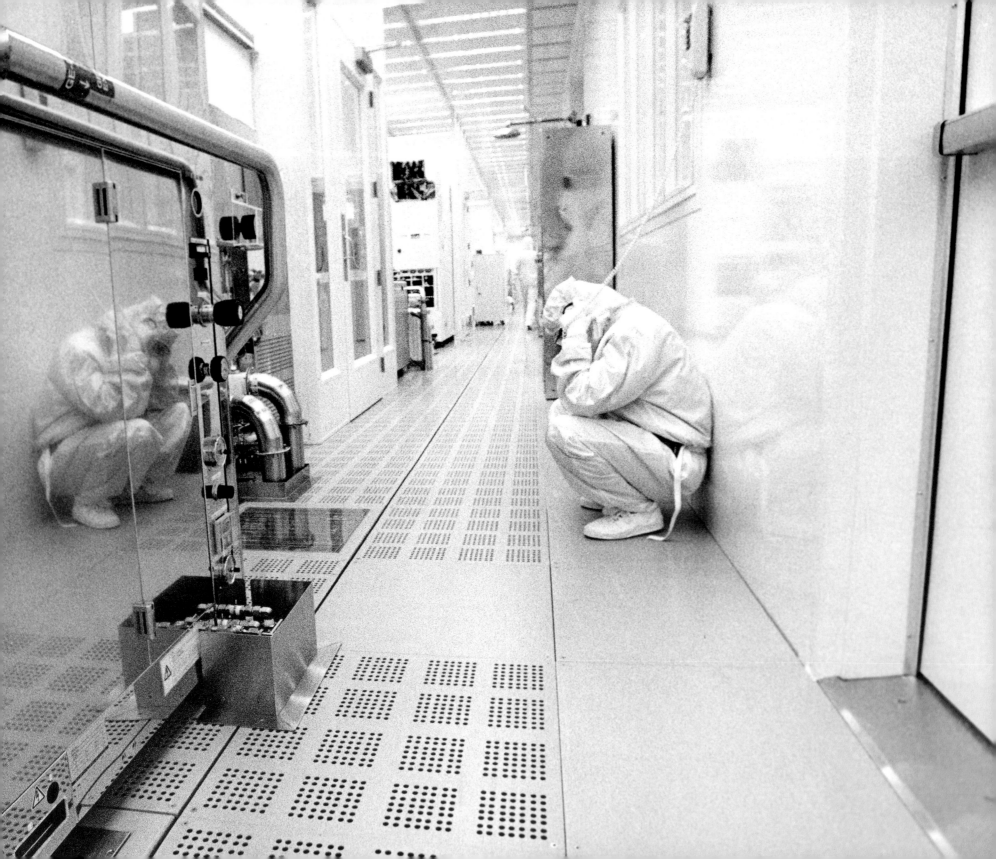

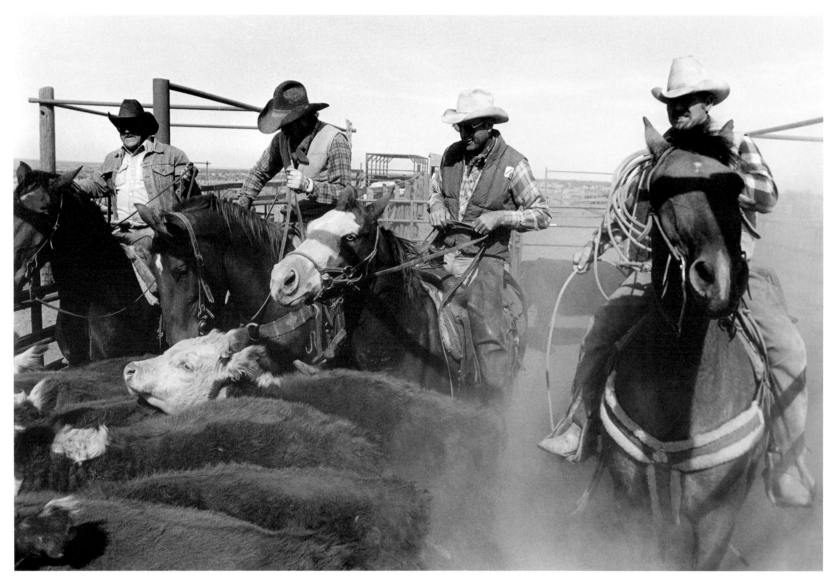

INTO THE CHUTE, MATADOR 1982

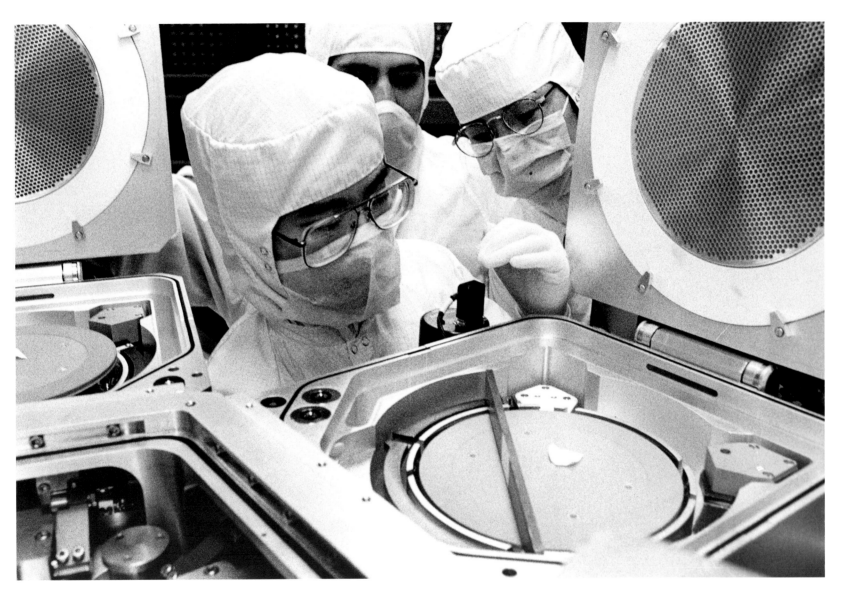

INSPECTION 1995

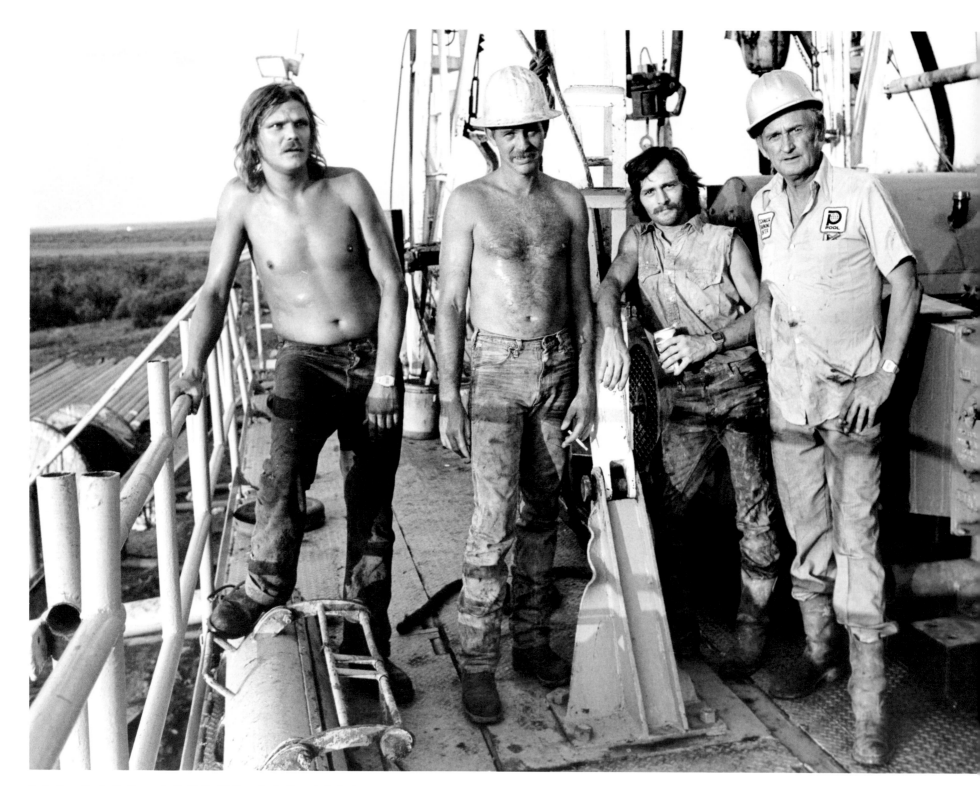

RIG GANG, JONES'S RIG 1984

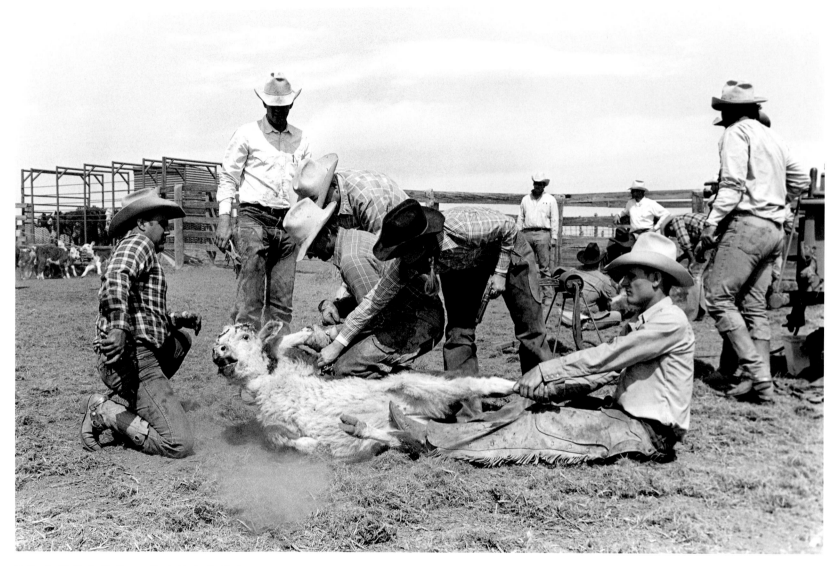

BRANDING, MATADOR 1984

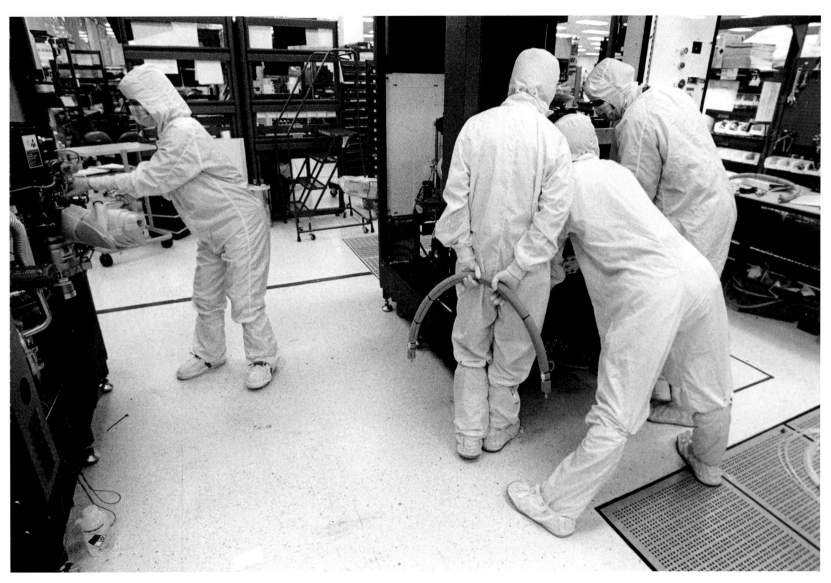

ASSEMBLY 1995

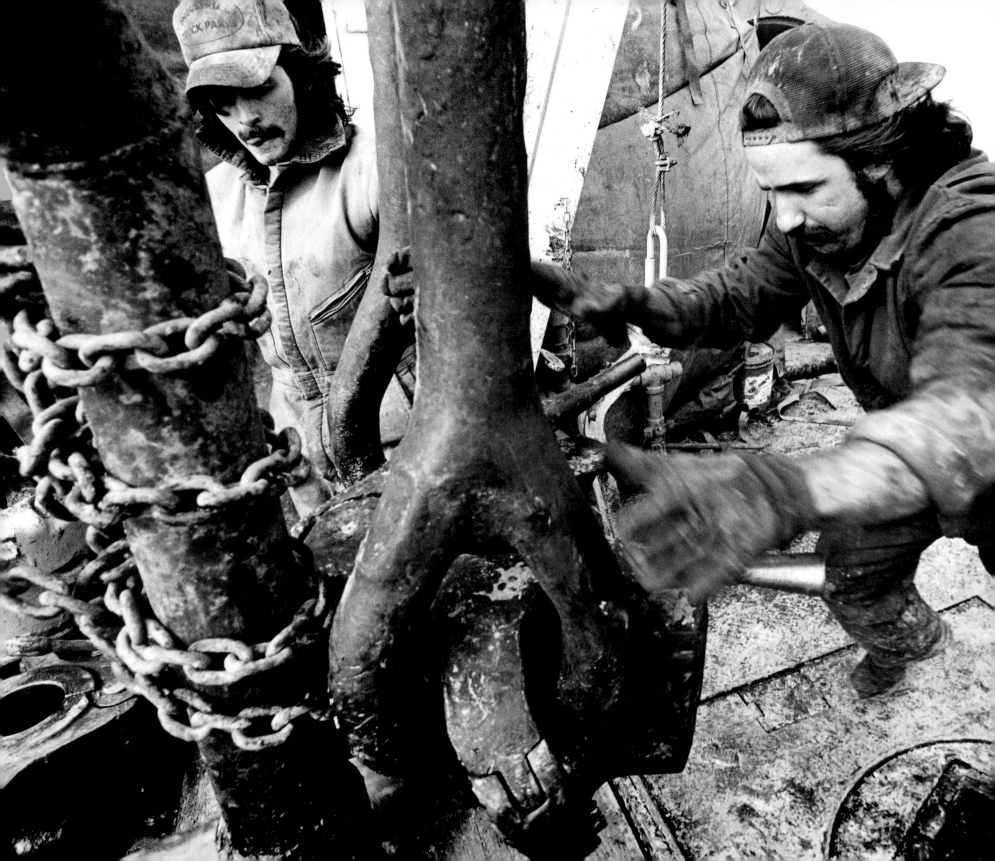

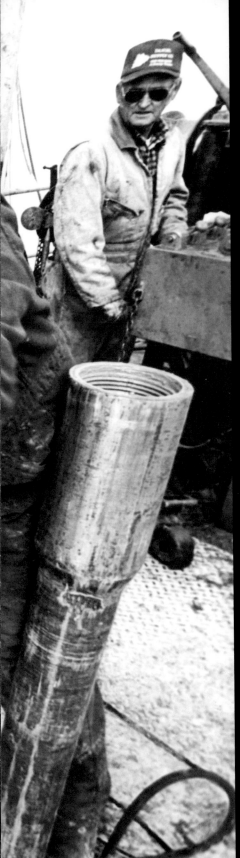

ON THE RIG FLOOR, JONES'S RIG 1985

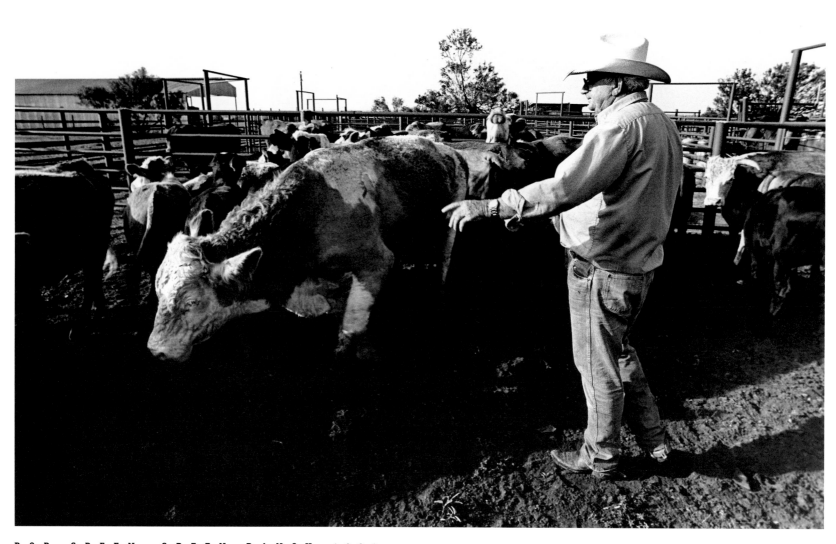

100

BOB GREEN, GREEN RANCH 1984

A.V. JONES, JONES COMPANY LTD. 1982

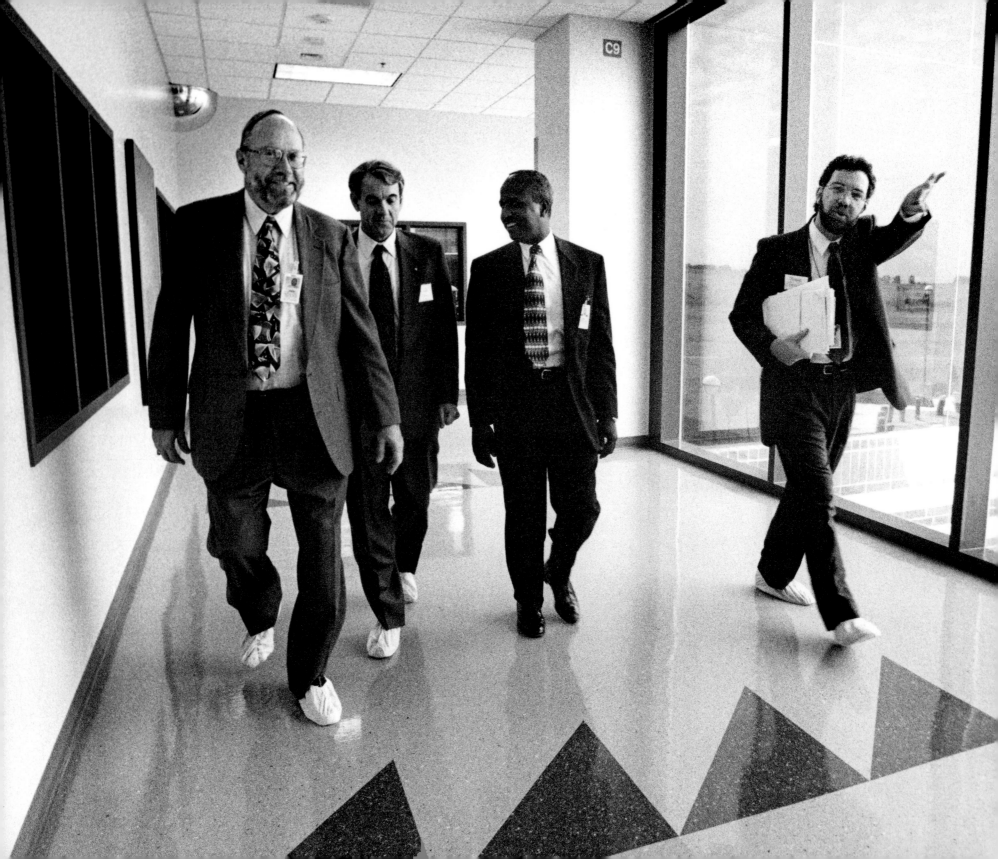

THE EXECUTIVES 1 9 9 5

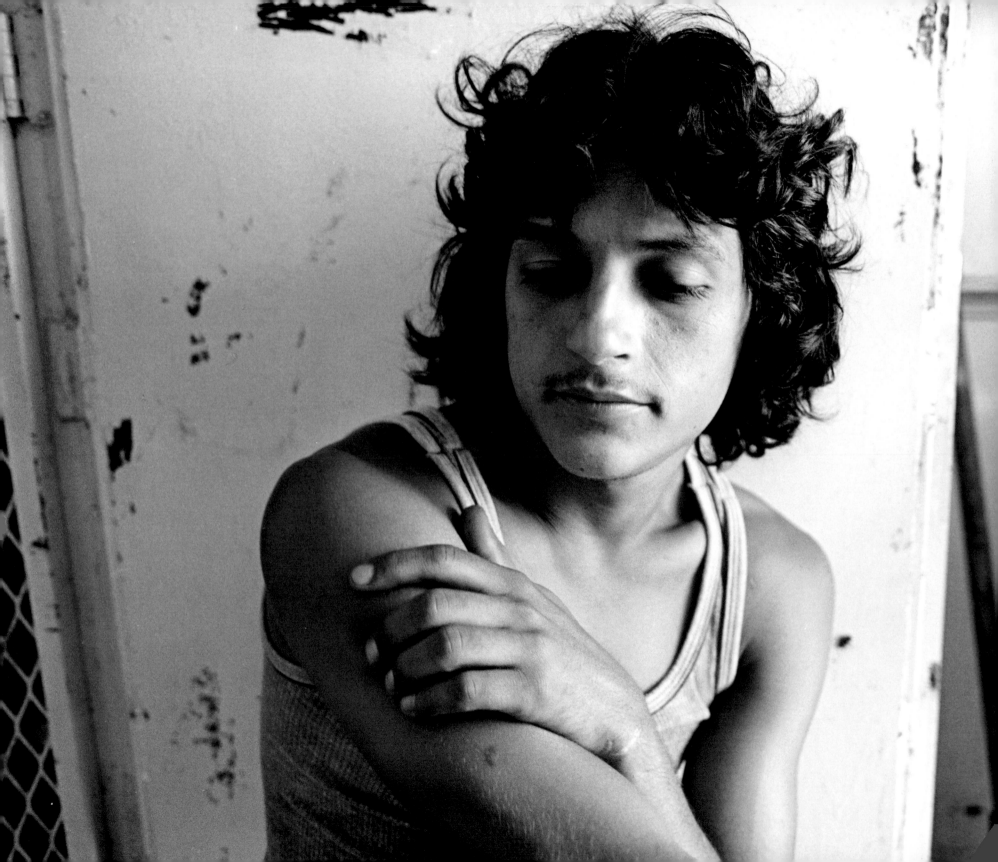

105

YOUNG ROUGHNECK, JONES'S RIG 1982

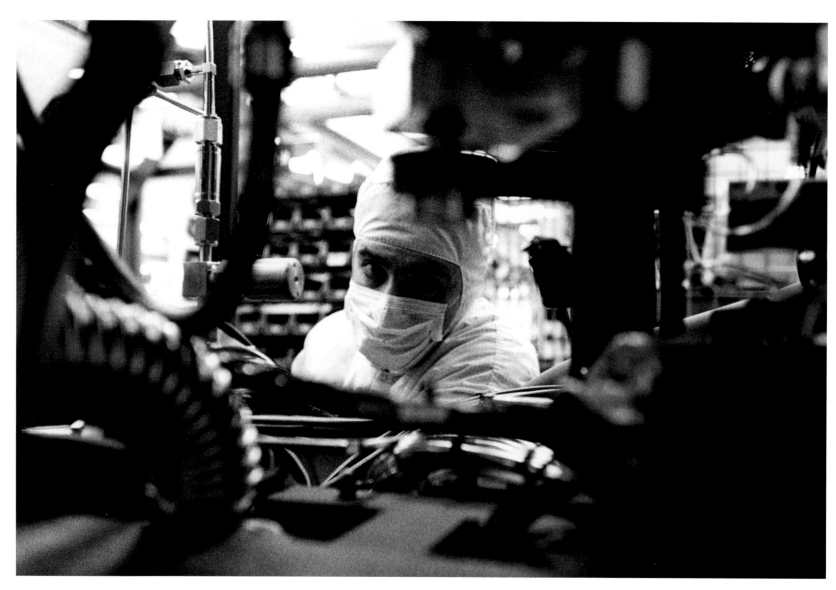

MAN AND MACHINE 1994

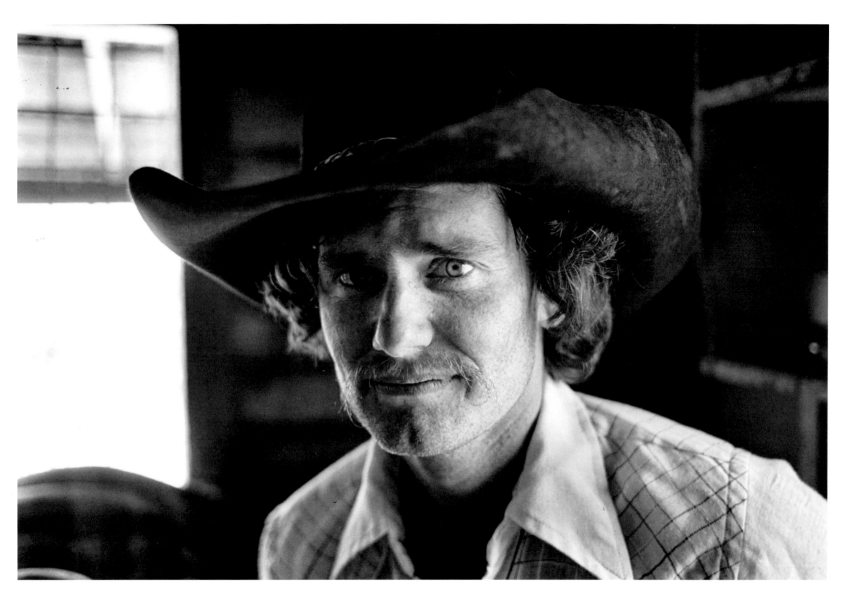

GARY HEBEL IN TACK HOUSE 1984

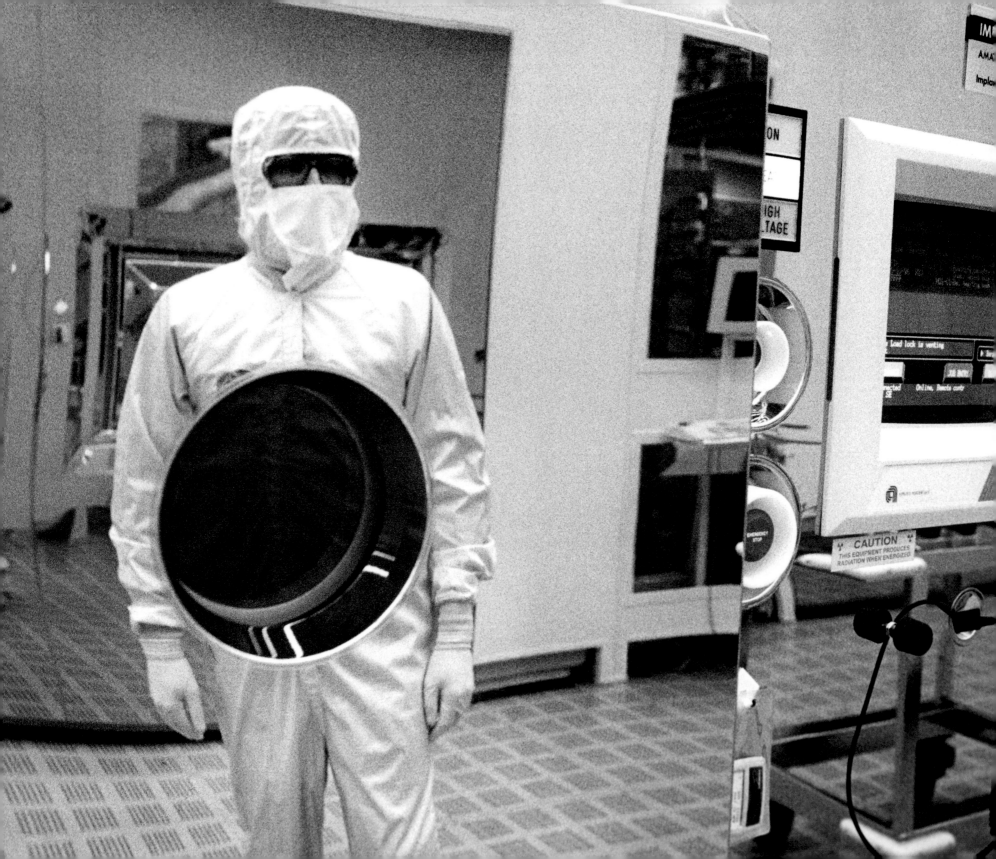

109

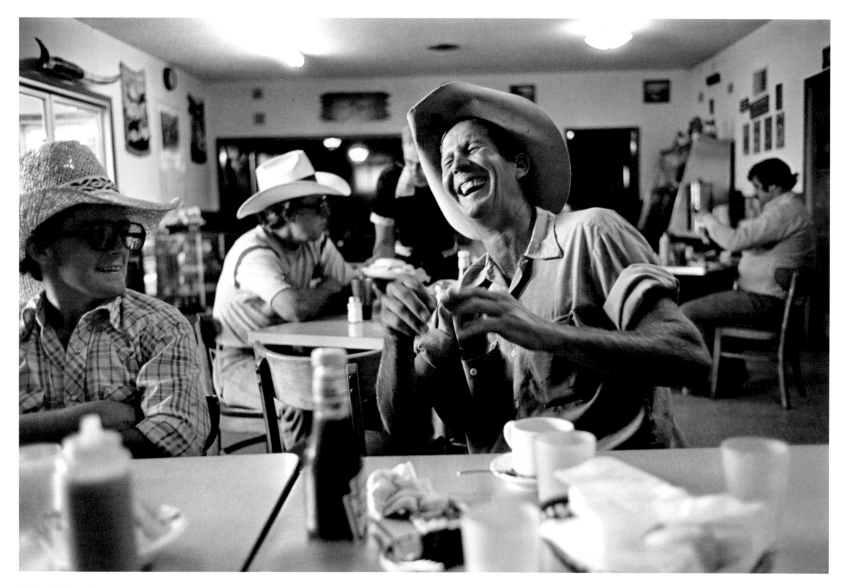

MELVIN AT THE LONGHORN CAFE 1983

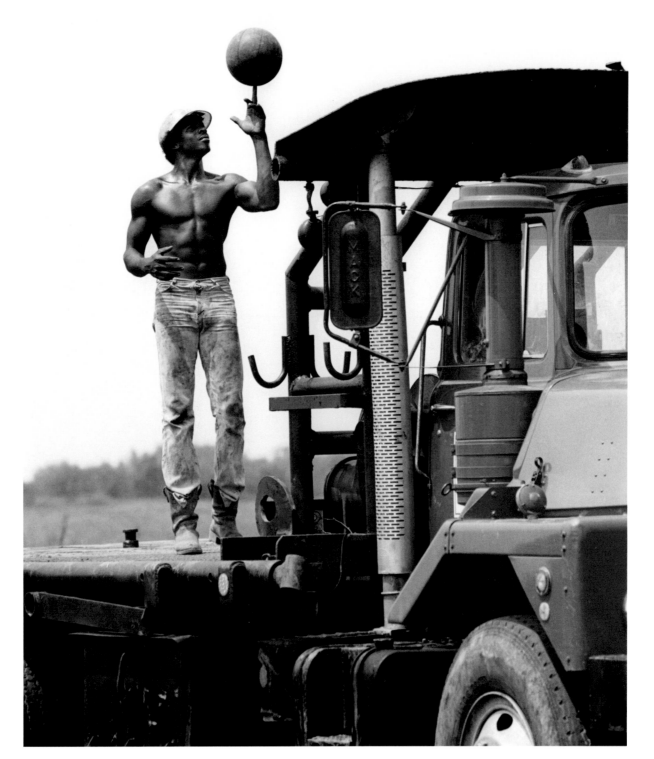

AFTER LUNCH 1981

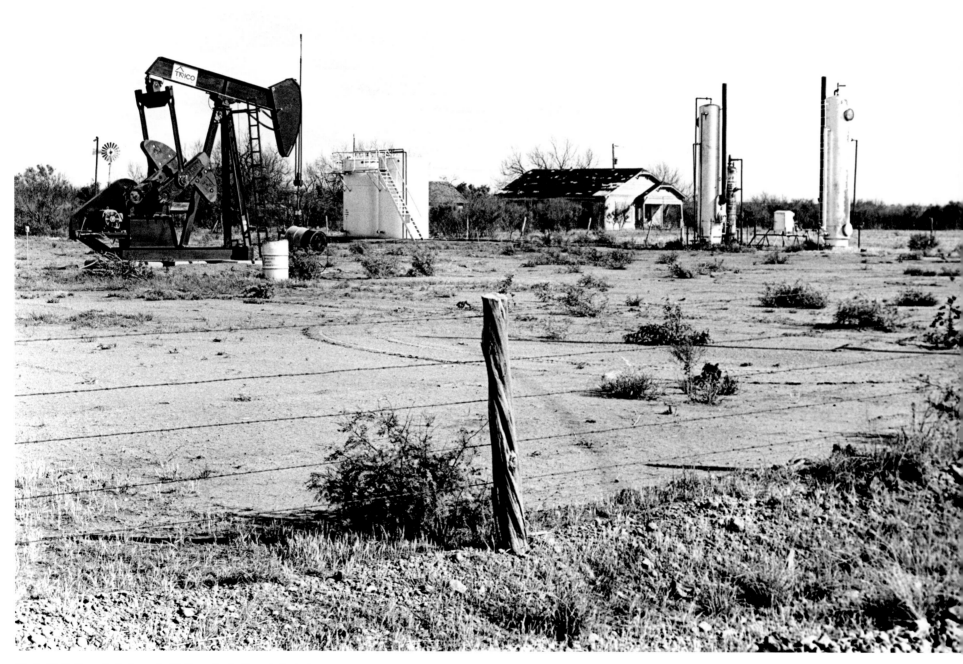

HOUSE OIL AND GAS 1986

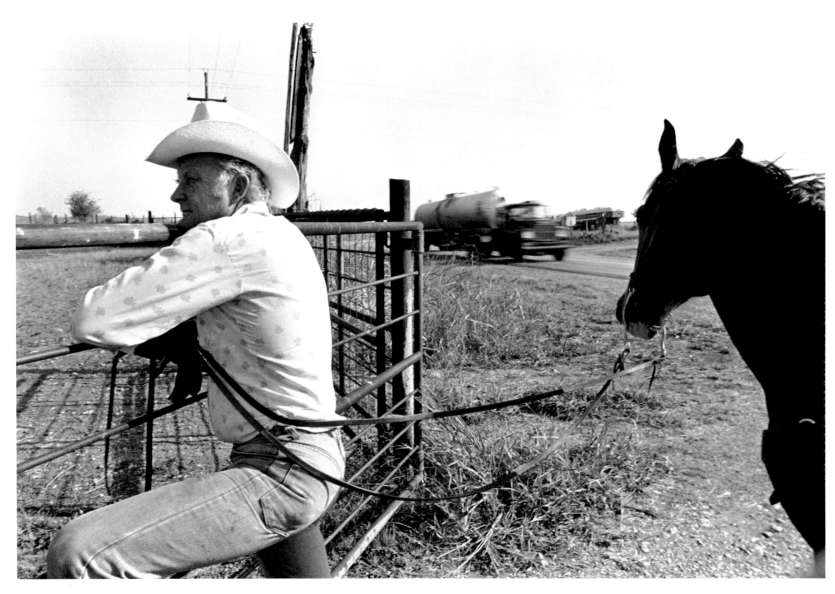

BUD, HORSE, AND TRUCK 1982

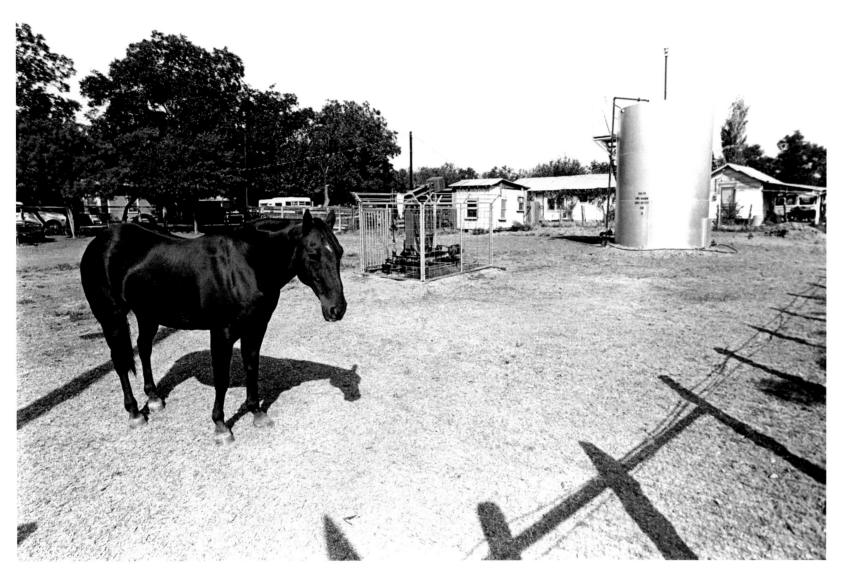

FENCED IN 1983

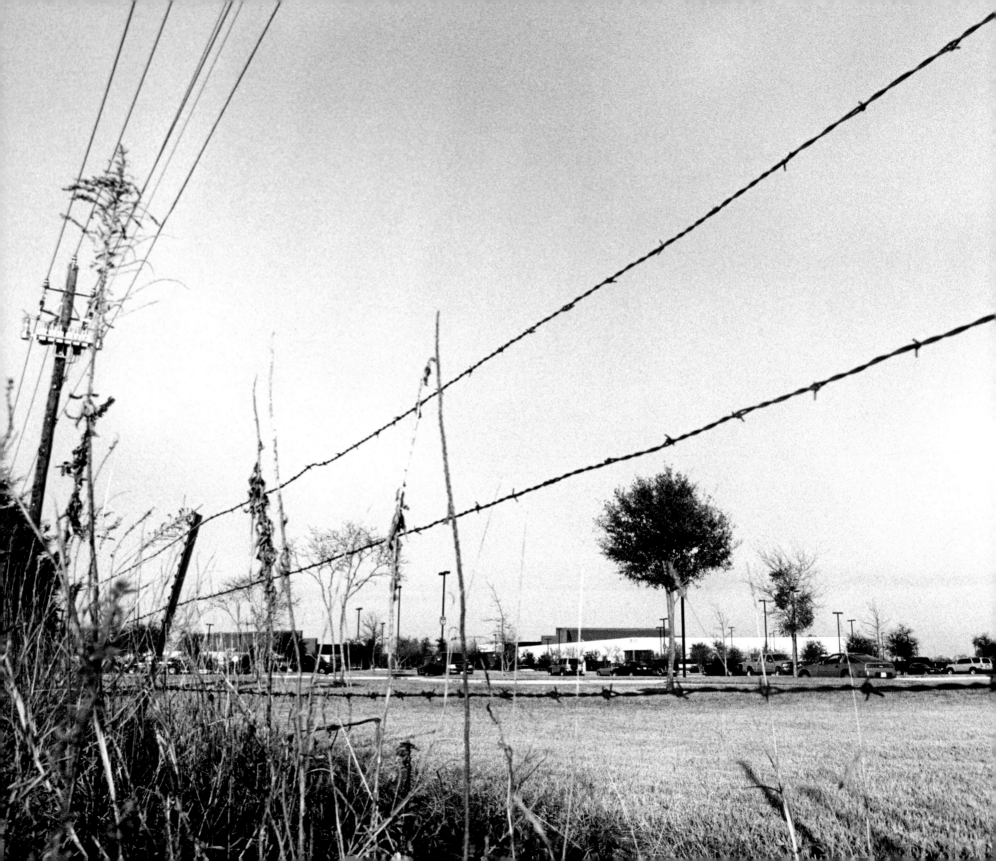

117

BEYOND THE BARBED WIRE, APPLIED MATERIALS 2000

WATT HANGS UP HIS HAT 1984

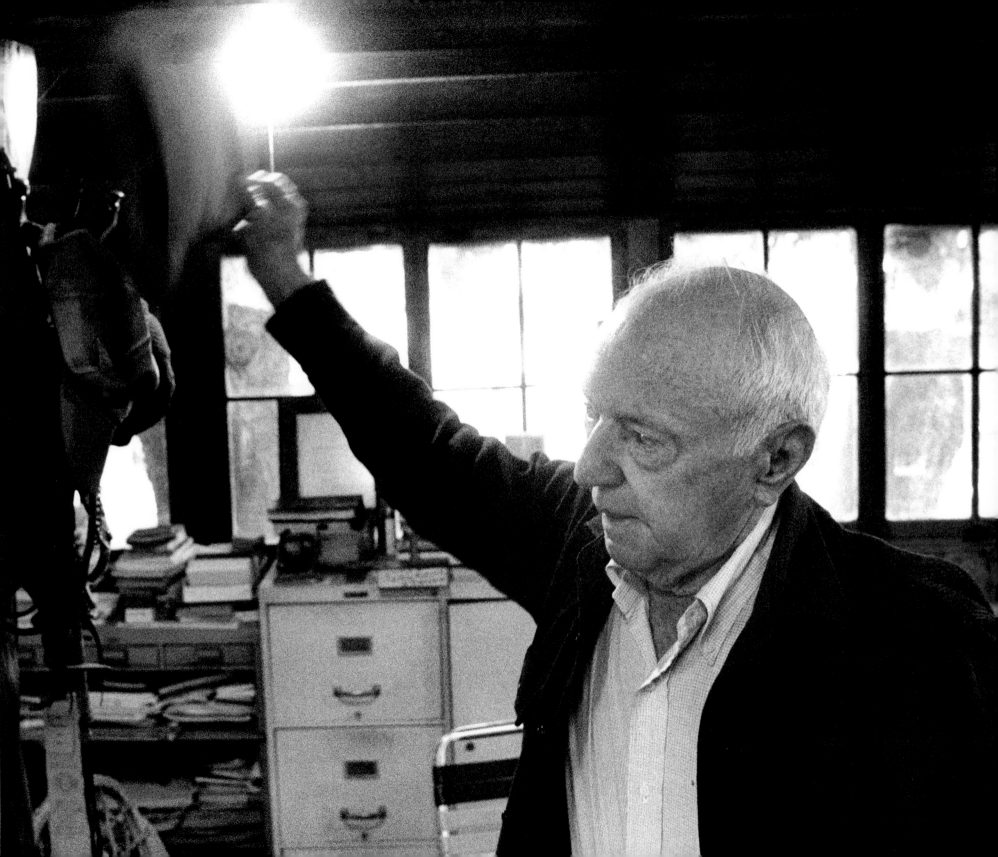

CHASING ROY ROGERS

I stood alone in pre-dawn stillness and looked up to the immense canopy of stars lighting the night wildness of the Great Texas Plains. My awareness shifted seamlessly from thought to wonder at the falling off of the earth into the sky, a stellar convergence of untamable natural forces shaping the land and all that lives, transforms, and dies upon it. I felt, profoundly and simultaneously, a sense of connection both to a remote insignificance and to eternal wonder. A primal conflict between the desire to do nothing and the instinct to run, to find shelter, food, and community held me suspended in place. I wanted to live, no, to transcend life as I knew it in this wondrous hostility between the grace of dawn and the dark power of night.

Moments before, I had for the first time stepped out of my car in front of Bob Green's ranch house in Shackelford County about twelve miles east of Albany, Texas. The cloud of red dust that rolled after me down the dirt road for more than eight miles enveloped my car, sticking to the gray wetness that blanketed everything. In contrast to the washboard bangs and bumps on the road and the pinging of gravel on the underside of my car, the dawn was still and silent.

A dim light glowed from a row of windows in the stone ranch house behind me. There were no signs of Bob Green or of the cowboys I was supposed to meet and to photograph for an assignment. Turning from the house, I walked to a barbed wire fence and peered into the vast darkness. From this hilltop I could see the faint glow of Breckenridge's lights ten or fifteen miles to the east and above the first glow of the false dawn. With my hands resting tentatively on the top wire between the barbs, my cameras on my shoulders, I waited. All around me, morning sounds, strange to my ears but known to my soul, began to rise with hints of dawn. A soft rush of feathered wings against still air flushed past my left shoulder. The high grass at my feet rustled with the movement of an unseen presence. In the distance a pack of coyotes yelped and howled as they chased across the pastures somewhere below me. I stood in silence, trying to discern the distant hills from the low clouds on the horizon where, for a time before daylight and dusk, the earth and sky are one.

Shortly after first light my solitude was shattered by the piercing whistles and yelps of men and the distressed bellows of cows and bleats of calves. I leaned hard against the fence post to discern their direction in the waning darkness. As I strained to see with the early light, I could make out a man on horseback some one hundred yards downhill from where I stood. He wore a large, black cowboy hat and a bright orange vest. Bennie Peacock moved slowly in and out among the low mesquite trees driving a few Hereford before him. Having grown up in Texas, I didn't expect to be awestruck by the sight of a cowboy. Yet there was something here that transcended my romantic notions of cowboys and the significance of my commercial quest. I knew that what I thought I had come for and what I had never expected were both out there somewhere.

Back on the job, I braced my 300-mm lens on the fence post and made one Kodachrome exposure before Bennie disappeared into the brush. It was not a compelling photograph. But it did initiate my work with my long-held interest in cowboy heroes, beginning a personal effort to embrace the contradictions and tensions between the myths and realities.

Many of my earliest photographs from this time were driven by Saturday morning memories of Roy Rogers and look like a love affair with textures and symbols and romantic myths. To me, Roy Rogers, like the western cowboy in general, is a symbol, a somewhat romantic icon that represents idealized values and inspires me to seek out and integrate those values into the self and the community. Though that's not what I thought I was trying to do at the time, I am convinced now, many years and many thousands of miles, experiences, and images later, that my initial, intuitive sense of the presence of something more profound than I understood that morning in 1980 was correct. After three days of commercial shooting, as I was leaving, Bob Green shook my hand, and invited me to "come back anytime."

Neither Bob nor I knew that his invitation would lead to an adventure that, for me, would last twenty years so far. Nor did we know that I would feel compelled to drive two hundred and fifty miles northwest from Austin over and over, to rise long before daybreak, saddle and ride in wide western prairies, and photograph cowboys working cattle. I did not know then that my experiences of those initial three days and Bob's kind words would awaken a personal quest that, until then, had lingered only in memories of watching Hollywood heroes.

When I did return early in the first year, I rode over hundreds of thousands of acres either on horseback or in a pickup, most often with Bennie and Gary or with Bob Green. I noticed that the ranches were dotted with oil storage tanks, pump jacks, and drilling rigs. In conversations with career cowboys, in contrast with those who did only day work or who subbed as roughnecks on the oil rigs, I encountered a distinct pride and attitude about cowboying versus working on the rigs. "My granddaddy and my daddy were both cowboys all their lives," Bennie once told me. "I'll always be a cowboy. I wouldn't pick up a piece of greasy pipe for nothing." This distinction is what initiated my interest in the two cultures in this particular area. Most of the oil companies were owned and operated by families who had settled in the area around 1930 and stayed there. Later I learned that they were an integral part of this traditional ranching area, fully integrated into the economic, social and cultural activities of the community surrounding Albany. Bob Green introduced me to oilman A. V. Jones, who agreed to let me photograph on his oil rigs.

Thus, during the first year of shooting, I focused primarily on a sociological connection between ranching and oil gleaned from conversations with ranchers, oilmen, cowboys, and roughnecks. I had begun to shoot on the oil rigs and to think about the larger picture of oil and ranching as the two primary economic forces in Texas since the early nineteenth century. The high-tech industry had just begun to develop in Austin, and it was not clear at the time that it would become the economic force that it has—and, consequently, the third phase of this project.

From the beginning, Bob and Nancy Green and their extended family welcomed me as if I were already a part of the family. This group included, but was by no means limited to, Bob's brother Bill and his family, West Texas patriarch Watt Matthews, oilmen A. V. and John Rex Jones and their families, Reilly Nail and Betsy Koch of the Old Jail Museum, and cowboys

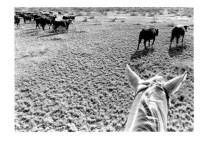

Bennie Peacock, Gary Hebel, and Melvin Gayle. They tolerated and, I'm sure, had a few laughs at my ignorance of their ways. They, and the roughnecks on Jones's oil rigs, showed great patience when I was so often in the wrong place at the wrong time.

More than once I chased a stray calf, on a full-tilt run, so far into the brush that it took Gary or Billy Green half an hour to round it up again. The first time I came back from such a chase, calfless but feeling more like a cowboy, Gary leaned over in his saddle and said, "Where's that heifer, Rick?" I thought he was just kidding me until I noticed that he slipped quietly out of the line and ambled slowly into the mesquite to outflank the stray and gently nudge it back to the herd.

Before I had fully learned this lesson, on another day I took off after an errant heifer in thick mesquite country with rolling hills. She immediately headed for the heavy cover, and before I knew it, I was whipping through thorn-laden mesquite branches on a downhill run. When I finally figured out I was not going to catch her, I pulled up my reins to stop and turn back. My horse ignored my inexperienced touch. She had her own ideas about that heifer. So on we went, faster and steeper. I felt her haunches drop from under me just as I saw the small creek the heifer had jumped. But it was not until I saw my boots rise above my horse's neck and noticed my camera floating in front of my face that I knew we were going to jump the creek, too. Whoa! Whoa! I screamed, more out of fear than command. By some form of grace, I managed to grab the saddle horn and find the power to pull my butt back into the saddle just as we hit the other side of the creek. The landing, of course, forced my entire body into the saddle in the most painful way. This was not the kind of grace and power I was looking for; nor did the event resemble the ideal visions of handling horses that Roy Rogers had taught me in my childhood.

As I rode back up to the pens where the rest of the group waited with the herd, Melvin looked at me with a tilt of his head and a grin. "That horse ain't got no brakes, Rick?" Later, in a kind, teaching way, Billy simply told me that sometimes it was better to ease around a stray so when it started to run, it was headed toward the herd instead of the other way. Eventually, these cowboys taught me many things about the intricacies of raising and working cattle, including how to catch and saddle my own horse. As I watched and photographed over the years, I did learn to stay out of the way most of the time. But I knew I would never ride as confidently in the saddle as they, or throw a rope deftly with such skill and accuracy, or throw and restrain a 400-pound calf without injuring the calf or myself.

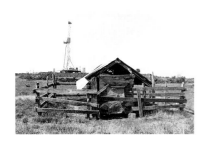

"'Bout three or four miles out the main highway, you'll wanna turn left on the second road. Run on that till you pass a Stassney oil lease road, and then swing left on a steep curve and go a ways. Just stay on the main road till you git to the top of the hill. Don't take none of the forks now; stay on the main road, then at the top a the hill you take a left and go—oh, maybe four or five miles or so. Anyway, there's an old house nobody lives in on the right and you turn left right across from that house. You should be able to see the lights of the rig from that hill and you just follow the road a mile or two and you'll be there. Just stay on that main road again or you'll end up out in pasture somewhere. Watch the lights on the rig."

There are no maps of these roads, and no two people who will give you the directions in the same way. Personally, I think it is sort of a sport some rural people enjoy visiting on those of us who are used to cities that are cut up into blocks and streets with names. It is not that the directions are incorrect. Any local could follow them like a pointer on quail. But, unless you have been there before, there is no way to distinguish the main road from any of ten roads that turn or fork off of it in any given mile or two. Rarely is it mentioned that these roads, and all of those you will mistake for the main road, are dirt roads and that there are abandoned houses or sheds every half-mile or so. Nor will you know that nearly all of the gated oil lease roads in this area are marked either Stassney or Jones.

So, again in the pre-dawn darkness, fifteen miles from town and in the middle of hundreds of thousands of acres of ranch land, the best information given was "watch for the lights on the rig." Fact is, if you can see the rig, sooner or later you can figure out how to get there. Fortunately the rigs generally are miles apart, so if you are in the general vicinity and see the lights, it is probably the right rig. If not, another roughneck will be happy to give you directions.

The first time I pulled up to a rig, I had no idea what to expect or where to go. These rigs are big. On one end and in the back are large mud holes and on the other end is the bed of an eighteen wheeler stacked with thirty-foot sections of steel pipe. In the middle is the rig itself, about eighty feet tall and surrounded by a steel platform about eight feet off the ground. On the front side of the platform is a small metal room called the doghouse. It is big enough to accommodate the five or six roughnecks when they are on their breaks.

It's cold in Albany in December and the wind cut through my blue jeans like I was not wearing anything. When I saw smoke coming from a chimney atop the doghouse, I mounted the steps, opened the steel door and stepped inside. A man of about sixty was standing between a machine printing a graph of drilling progress and a door at the other end of the doghouse. He was yelling to workers out on the rig floor. I walked up and stood by the machine, close to the heater, and waited for him to acknowledge my presence. He looked at the graph, grunted to himself and walked out the door. He did not return.

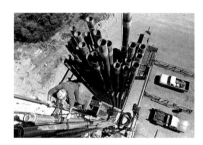

I stepped just out of the door and was greeted simultaneously by a hard, cold wind and the deafening, revving roar of the unmuffled drilling engine, above which no human voice could be heard. One man, whom I later learned was the driller, held a handle that controlled the engine. He watched as two men on the platform moved massive mechanical arms and cables and chain in repetitive, dance-like movements to the tempo of the driller's rhythm on the throttle.

Sixty feet above the steel deck a man worked on a small platform, leaning precariously into the open space of the rig, to wrap a smooth rope around a sixty-foot length of drilling pipe and finesse four thousand pounds of steel into a rack behind him in a tenuous but choreographed concert with his partners sixty feet below. Here, on this steel tower above the prairie, was the same sense of grace and power that I had found in the movements of cowboys on horse back and on foot among moving livestock and the arch of ropes in the air. Here also, on the same prairie land, I experienced seemingly disparate things working in concert, both symbolically and physically, toward some sense of unity and for the greater good of the community. The continuity of these experiences connected ranching and oil in a way I had not considered before and reminded me of the idea of balance and of the ideals for which the character of Roy Rogers stood.

Though I was not allowed to participate directly in the roughneck's work on the oil rigs, I managed to get into the middle of the rhythm of the work long enough to get the images I wanted. Once, I was busy photographing, moving here and there to avoid large swinging stands of pipe or machinery, when suddenly I noticed that all of the work had stopped; no one was moving except to turn and look at me. I turned to the driller, who nodded toward the platform and the loose cable between my feet that was about to be stretched tight at a level of four or five feet in the air as soon as I stepped out of the way. It didn't happen again and no one ever mentioned it. I knew a few of the rig hands by name, but most moved from rig to rig often enough that I rarely saw them twice.

Initially I thought in broad terms of rural and urban cultures, values and traditions: of how Texas and most of the agricultural states were changing from rural to urban socialscapes and about what effect that change had on traditions and

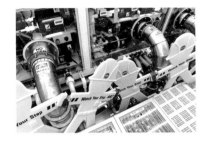

values and related behaviors and lifestyles. It was clear to me from the beginning that the land and the history of the land and the people were significant forces in the lives of the Greens, Matthews and Nails, ranchers whose families had settled and worked this land since the 1840s. The oil families were newer to the area. The Joneses and Stassneys had settled in the Breckenridge and Albany area as wildcatters in the 1920s and 1930s, and their families were now a vital part of the local economy and culture. They were also closely associated with the land, but in different ways.

The Great Plains run east to west from the break of the piney woods of East Texas to the foothills of the Rocky Mountains. Albany is just east of the approximate middle of this expanse, and Austin is about 250 miles southeast but still on the same great prairie. To move from the dung-dust ground of the corrals and horseback forays into the vastness of these prairies to the self-contained, hard-scraped earth platforms and the steel floors and doghouses of the oil rigs is a startling but comprehensible transition in time and space. Cattle and oil have been linked as the two icons of Texas mystique and power for more than a hundred years. But there is a newcomer to these vast plains that has outstripped both in terms of human endeavor and economic power. To make a jump from the saddle and the oil rigs into the sterile, high-tech micro-processing fabrication facilities known as fabs or clean rooms is almost an insurmountable leap for the uninitiated. Here, things that most Texans had never imagined a decade ago are part of the daily routine to thousands of new technology pioneers.

Though the modern castles that house clean rooms rise from the same pastures and grasslands that Texas Longhorns once trod, the grass is clipped short and the cuttings are not bailed. The Bermuda and St. Augustine wind along parking lots and sidewalks to steel and glass revolving doors that shut out the prairie winds and the dust. If you are escorted, visitor's badge prominently displayed, beyond the guard at the visitor's desk, through the labyrinth of halls and gray, cubicle offices to the first door of the fab, you will know, from the sticky-paper on the floor and the paper covers on your shoes, that you have been seamlessly transported into the ever-evolving revolution of our technological future. This is the place where time and space are measured in nano systems and electronic pulses travel circuits on the ion highways embedded in silicon wafers.

Beyond this first entrance, a buffer zone in which visitors glimpse the barest facade of the microchip process through sealed glass windows, there is neither unescorted nor unsecured entry. For those who do enter, street clothes and personal belongings are secured in lockers and exchanged for hair and beard covers and form-fitting, lint-free garments resembling long underwear and special white shoes. Hands are washed and dried in enclosed blowers and immediately covered with lintless glove liners and then latex surgeon's gloves even before gaining access to the dressing room. Minimal camera gear is allowed and all that is must be thoroughly wiped with sanitary cloth saturated with acetone. Film canisters are wiped and sealed in plastic bags. The camera pass is clearly displayed and the photographer does not leave the presence of his escort. In the dressing room, a clean, nylon "bunny-suit" is extracted from sealed plastic containers and the human frame is covered from head to toe, only the eyes remaining uncovered, momentarily, before being fitted with goggles.

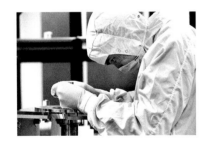

From this point all the novice encounters is "bunny-suited" technicians, one indistinguishable from another by gender, name or rank. It is a wondrous world of things undreamed and nearly incomprehensible to everyone except engineers. This is a world where silicon wafers are transported by robotic systems and arms from one process to the next by the touch of computer keystrokes. Inside of one sealed system machine, acid etches and transforms shiny, silicon wafers into computer chips. In another micro-cannons implant arsenic ions into silicon chips to form the circuits for electronic impulses that travel these micro highways of information technology.

Yet, surrounding this robotic micro-world are the individual technicians who don the bunny-suits and work all day in these sterile, monochromatic environments. It is they, highly trained and precise, who type the commands to make the acid flow and the ion canons fire. Though they seem anonymous to me in their white body suits, they recognize one another instantly and work together in homogeneous teams like the roughnecks and cowboys do. Each team is an indispensable part of the process of producing either the machines that make computer chips, the chips themselves or the consumer products in which the chips are used.

The imminent dangers inherent in working cattle or drilling for oil are not apparent in the clean rooms. There are neither wild animals nor swinging mechanical arms that I or the workers have to be aware of. While photographing here, I was more concerned that I might disrupt a test process or cause damage to a multi-million dollar machine than I was for my own safety. Chains do not whirl and ropes do not fly and rugged men do not dance in this sterile chamber. Thus, the symbolism and the interplay of grace and power that unites ranching, oil and high-tech, beyond their economic, ecological and cultural connections, is more subtle. But even here the same balance of grace and power exists. It exists in the emergence of human gesture and relationship among seemingly anonymous and androgynous forms working together. It emerges in the relationship of those human forms to the chrome and steel of extraordinary machinery. Here, a graceful, gloved hand pauses, momentarily, against the dark, circular background of an open etch chamber. There, eyes glance from the midst of tangled cables and hoses. The dangling feet of bunny-suits hanging in the dressing room huddle together on the cold, tile floor.

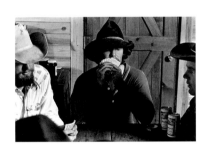

Ten years passed between the time I first photographed cowboys and roughnecks and the day Steve Taylor, at Applied Materials in Austin, hired me to photograph high-tech clean room workers in 1990. It was even longer before I began to make connections, and see contradictions, among all three groups. When I first talked with Steve, I showed him the cowboy and roughneck work. He looked at it carefully and told me he wanted me to photograph the Applied Materials workers "just like you photographed the cowboys and roughnecks." By this time, the high-tech industry represented a strong force in Austin but did not approach the economic power structure nor the iconic symbolism that ranching and oil had dominated for over 150 years. Within less than a decade this high-tech industry grew exponentially, not only to overtake ranching and oil in Texas but also to become the largest employer and the strongest economic force in the state. Applied Materials, Advanced Micro Devices, Motorola, IBM, Dell, Samsung, and literally hundreds of smaller and newer companies have expanded the Austin metroplex into adjacent counties, surrounding outlying rural communities and transforming once-fertile farm and ranch lands into what is now known as the Silicon Hills. In less than a decade, high-tech has changed the face, the character, and the soul of Texas.

The connections and contradictions among these workers of the three primary economic forces that have shaped the history and socialscape of Texas are significant to us all in ways that lie far beyond our economy. Their impact is personal, historical, cultural and symbolic. They manifest a dynamic tension, a microcosm of the historic struggle of humankind to balance economic, social, and personal concerns in our evolution from an agrarian, to a mechanical, to a technological socioeconomic landscape.

Strange bedfellows, this group. Yet so connected are they to the fact and fiction, the fair and the foul, the land and the people, the past and the present of Texas mystique and culture, that they shape our perceptions of history and the reality of our future, both as archetypal legends and as socioeconomic forces.

I have spent nearly half of my life knowing and photographing people at work on the fields of the Texas plains and grasslands. In these pictures of them lie implied connections among the wide skies of the western grasslands, the hard, steel decks and towers of the oil rigs, and the sterile, white-suited environment of the high-tech community.

All these people generously opened their lives to me and to my camera. They taught me things I had never expected to learn about the integration and transformation of urban and rural cultures—and about myself. They gave me the opportunity to chase my dreams among them as they went through their all too-real daily lives. In doing so, I found out that heroes rise and fall as high and hard as the bad guys—that there is a little of both in all of us, and that the challenge is to find the tenuous, but dynamic, balance between grace and power that exalts both as one.

With my camera, I intuitively found that balance in the graceful, dance-like movements of hardened cowboys riding and working cattle, in the smooth, rugged reach of roughnecks throwing steel chain or stacking pipe, and eventually, in the high-tech clean rooms where white-suited technicians milled tiny parts, bolted huge cylinders onto chrome machines, and pushed computer buttons that distributed acids and implanted ions to make computer chips.

Roy Rogers was not a Texan. But, as a cultural symbol, an archetype, he represents the values that many Texans have long agreed are essential to successful community life and that are worth passing on to their children and their children's children. Roy represents the ability to face and to overcome adversity and hardship, to know right from wrong, to be compassionate, yet honest and to work for the common good of the community. He represents the kind of personal integration individuals must possess to develop a balanced community. He represents integrity, both personal and corporate.

Some would challenge and marginalize this concept as overly romantic. However, I believe they would be short-sighted to do so. All archetypal figures are romantic in that they represent the highest ideals to which a group aspires—ideals which are, for the most part, desirable but unattainable. As long as there have been communities, there have been such mythological heroes who represent the story that holds the traditions of the people. The purpose of tradition is to give people cause to reflect and to remember who they are, where they came from, what values are important to them, and why they do what they do together. Traditions help make communities viable and dynamic by setting standards that inspire people to think about what is valuable and worth passing on and what should be changed and discarded. As the pace of our world increases in this technological age, it is critical that we take the time to reflect on the effects of change on the balance of grace and power in our lives, individually and communally.

So, as it turns out, Roy Rogers is indeed a part of Texas mythology. He was both a real person, Leonard Slye, and is still an archetype of personal integrity. He symbolizes the traditional values that are worth passing on. As with Roy's Choctaw ancestors and with Roy himself, those primal values begin with the integrity of the individual and the sharing of that integrity from the prairies to the board rooms across the Texas plains and beyond.

Happy trails, Roy.

List of Titles

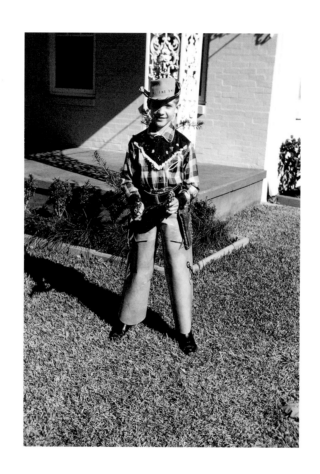